*Wedding Photography*

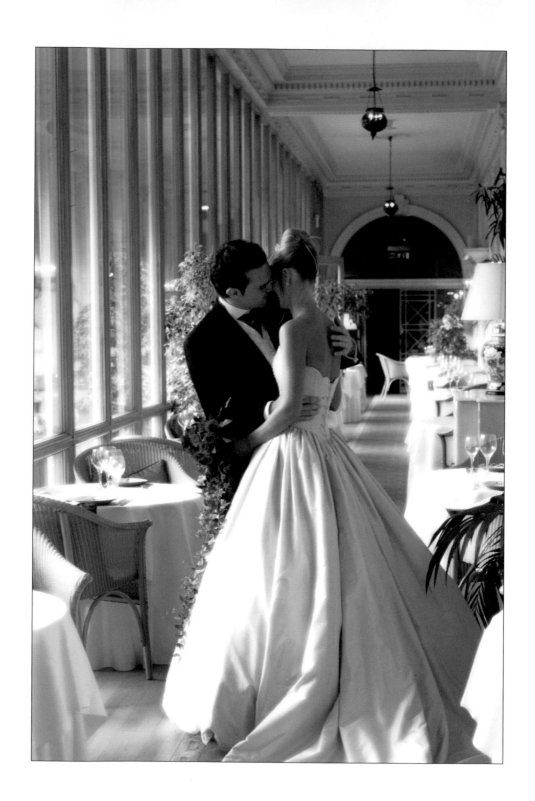

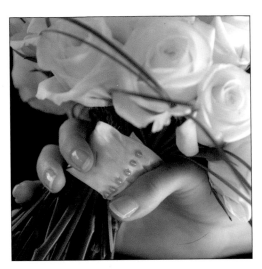
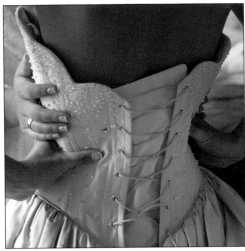

# Wedding Photography
## *A Professional Guide*

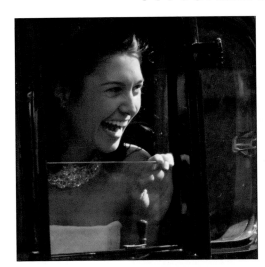
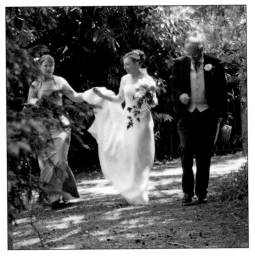

## *Morag MacDonald*

Argentum

*I dedicate this book to my family.*

First published in Great Britain 2007 by Argentum, an imprint of
Aurum Press Ltd, 25 Bedford Avenue, London WC1B 3AT
www.aurumpress.co.uk

A catalogue record for this book is available from the British Library.

ISBN  978 1 902538 47 1

1       2       3       4       5       6       7       8       9       10
                2007    2008    2009    2010    2011    2012

Designed by Toby Matthews, toby.matthews@ntlworld.com
Packaged & Concept by Angie Patchell
at angela patchell books, angie@angelapatchellbooks.com

Printed in China By SNP Leefung Printers Ltd

# Contents

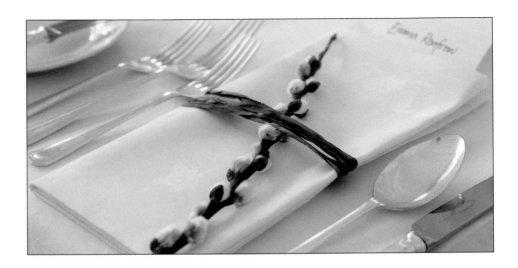

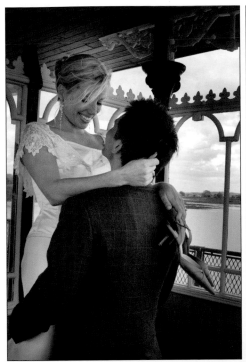

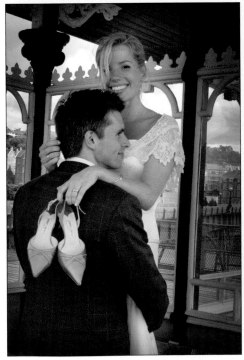

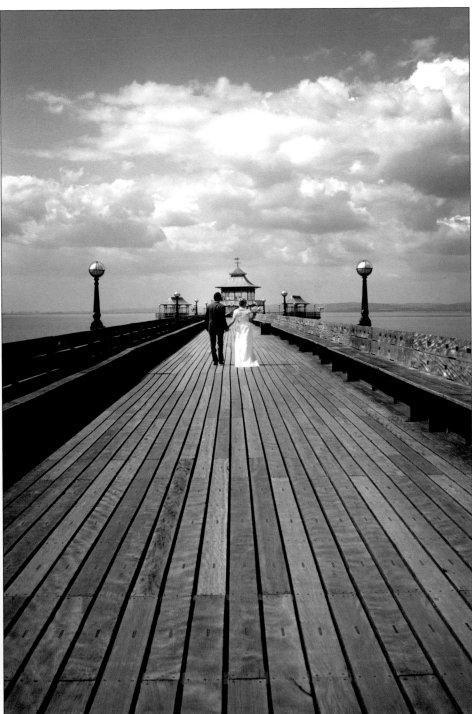

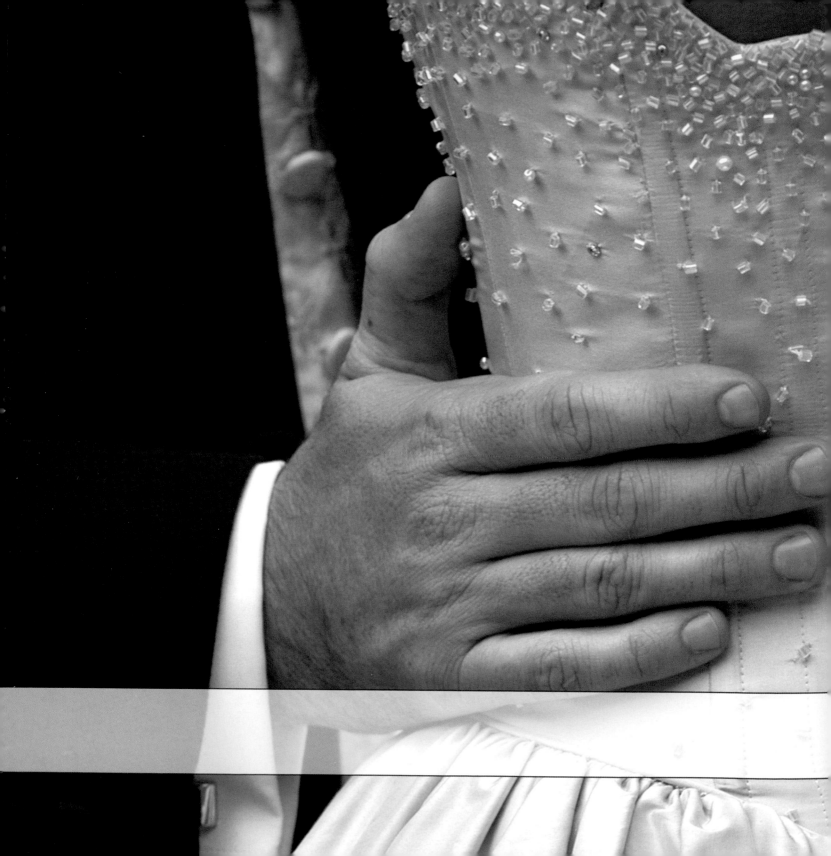

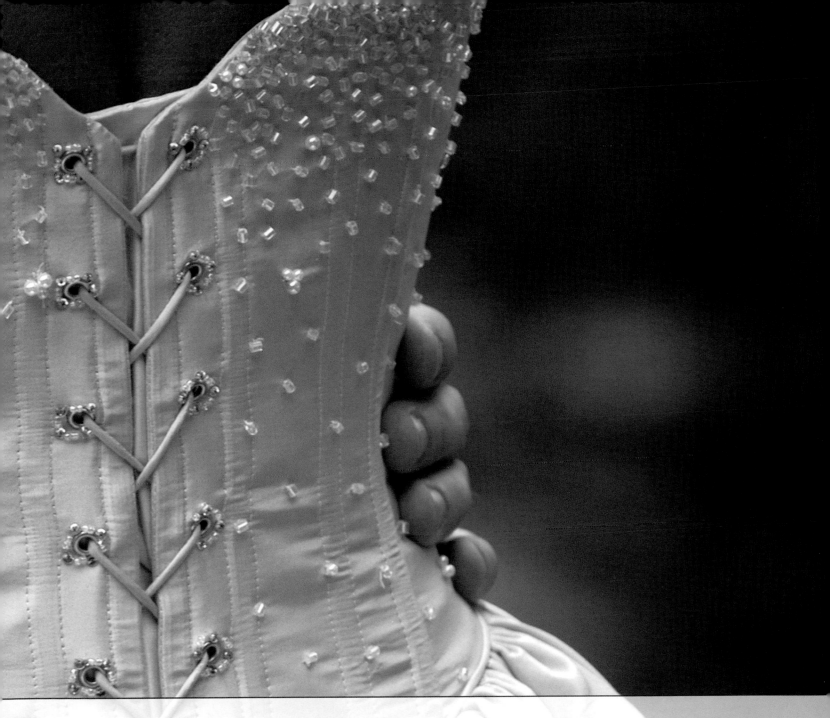

*Introduction*

**One of the greatest achievements in life has to be finding a way to earn a living doing something you really love. Photography is that to me. I have always been passionate about it and feel so lucky to be have been able to pursue this passion and turn it into a successful career.**

*Photography is about the art of observation. It is the ability to pre-empt a situation, visualise the image and press the shutter at the moment all of its elements come together. The linking thread between Henri Cartier-Bresson's talent for capturing the 'decisive moment' and today's press photographer who can tell a whole story in just a few shots is the ability to think, see and act with precision.*

*Whether the art of observation is something that can be taught or whether it is inherent in the photographer, it is a skill that can be sharpened and perfected. The modern bride and groom expect their wedding photographer to be able to produce beautiful, stylish images that tell the story of their day with little disruption. Today's photographer needs to be organised, creative, passionate and able to work in a fast, friendly, unobtrusive manner.*

*The true photographic artist will not only create stunning images, but also be able to bring the images together as a coherent narrative. The final album should show the events unfolding like a cinematic storyboard. The pages should work in harmony and reflect both the personalities and the ambience of the day.*

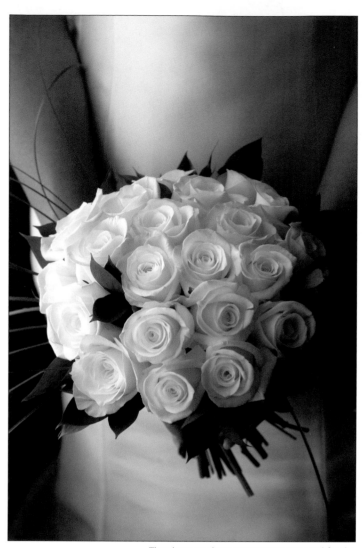

The shots on these pages were exposed for the natural light coming in through the window of a hotel room. I chose to frame tightly and sink the room behind into shadow as it was full of distracting pattern. The resulting shots have a peaceful presence that is enhanced by the bride directing her gaze away from the camera.

*All images on these pages:*
*Nikon D2x,*
*28-70mm f/2.8 Nikon ED lens,*
*ISO 640,*
*1/125sec at f/4*

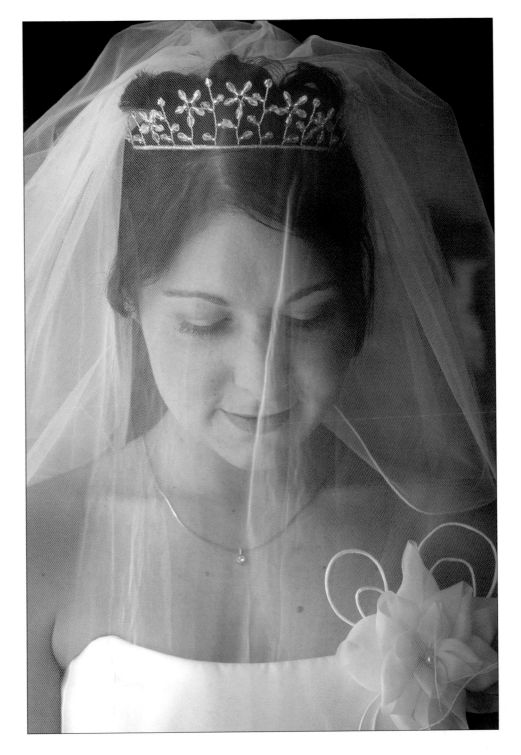

*Technical skills with the camera are just one aspect of the profession; today's wedding photographer also needs to be a photojournalist, artist, stylist, director, Photoshop technician and graphic designer. Even these capabilities do not go far if you are not a great communicator. You must be able to empathise and put your subjects at ease in your presence in order to create the quiet, intimate and beautiful close up images that will make your clients' albums stand out. You will also need the authority to direct group shots so they happen in a quick and fluid manner and the confidence to ask for the shots you want.*

*With time and experience, all of these skills will come as naturally as pressing the shutter at the decisive moment, but we as photographers should never overestimate our expertise. We should never stop looking or learning from what is around us.*

*One of my greatest pleasures is looking at photography and art. By seeing how other people use the light to create their images, I am constantly spurred on to try new things as something I have seen sparks an idea. To keep your photographic practice fresh and up to date you should be looking at images wherever you can. Whether you visit galleries and exhibitions, read style magazines or extend your library of books, keep your eye trained, your talents up to date and never stop looking.*

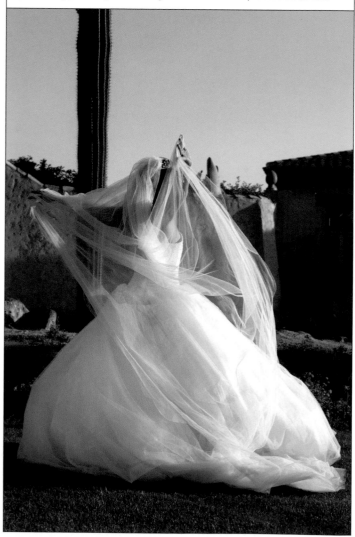

LOW evening sunshine has a different quality and colour temperature to midday light. When back lighting your subjects, it is very easy to get lens flair due to the low angle of the sun. Using a good lens hood and positioning your subject at an angle to the sun will help cut down on flair.

*Right:*
*Nikon D2x, 28-70mm f/2.8 lens, ISO 200, 1/850sec at f/5*

*Opposite page, top left:*
*Nikon D2x, 28-70mm lens, ISO 200, 1/350sec at f/5*

*Opposite page, bottom left:*
*Nikon D2x, 28-70mm lens, ISO 200, 1/750sec at f/5*

*Opposite page, right:*
*Nikon D2x, 28-70mm f/2.8 lens, ISO 200, 1/400sec at f/5*

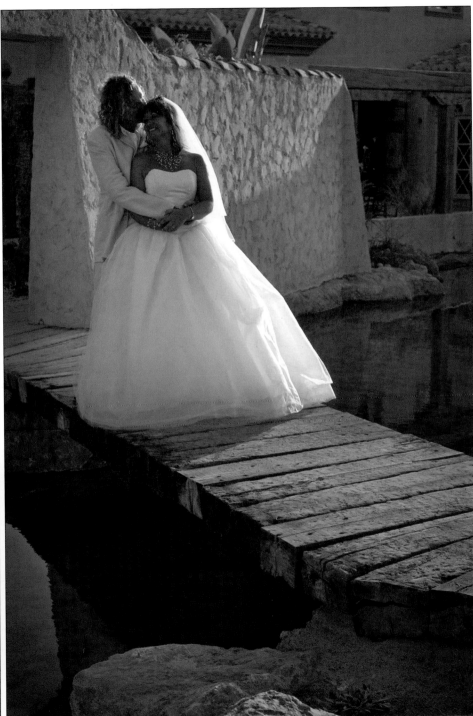

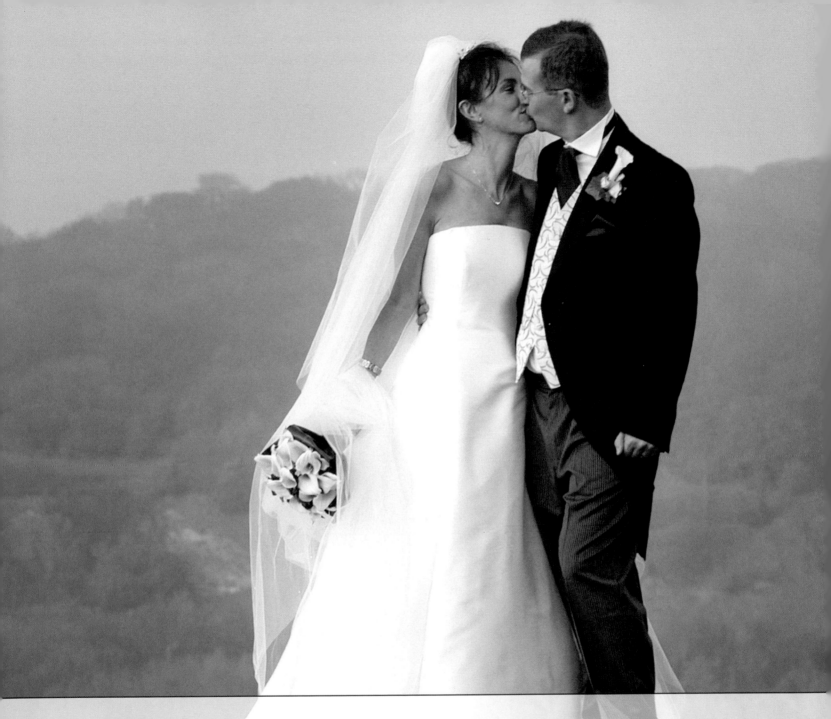

**Chapter 1** *Planning and Equipment*

# Equipment and Preparations

**Equipping yourself as a wedding photographer is a big investment, but vital to ensure you have the versatility to cope with any situation a particular assignment might throw at you. Whatever equipment you choose, it is vital to get to know it so that you are able to work intuitively. You need to be completely confident and at ease with every piece of equipment in your camera bag.**

*I sometimes shoot with two camera bodies each with different lenses attached, but often leave the back up camera and flash gun etc, in the back of the car to save carrying the extra weight. Choosing to shoot by available light, or with on-camera flash, means that I am able to move around freely when composing my shots. The studio flash equipment is rarely used, but it is reassuring to know it is there in case of poor light or heavy rain. Right is a list of all the items I carry.*

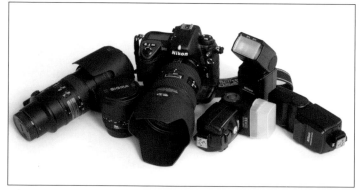

Nikon D2x with most used lenses, Nikon 28-70 2.8 AF-S, Nikon 70-200 2.8 VR and Sigma 15mm EX fisheye and a selection of Nikon Speedlights.

## Equipment List

✓ Nikon D2x camera body.

✓ Nikon D100 body (used as back up in case of camera failure).

✓ Fully charged spare camera batteries.

✓ Nikon AF-S 28-70mm f/2.8 lens.

✓ Nikon AF-S VR 70-200mm f/2.8 lens.

✓ Sigma 15mm f/2.8 180° fisheye lens (the magnification of my digital camera does not allow for a true fisheye perspective, but the images are still great fun).

✓ Tokina AF 19-35mm f/3.5-4.5 lens.

✓ Nikon SB800 flash head

✓ 2 × Nikon SB600 flash heads (these may be used off camera, to back light remotely, controlled with SB800 on camera).

✓ Manfrotto 144 (a sturdy tripod is important, especially when using long lenses).

✓ Manfrotto 222 pistol grip head.

✓ 4 × 2gb memory cards (I use cards from Lexar and San Disc, which are high quality and come with image recovery software).

✓ 6 × 256mb memory cards.

✓ A multi pocket card holder.

✓ Lens cloth.

✓ Bowens Esprit 500 twin flash head kit with white umbrellas, softbox and lighting stands for above (stands may also be used with SB600 flash heads to give easy backlighting when using flash).

✓ Bowens Pulsar radio slaves × 3 (one attaches to my camera and the others to the Esprit flash heads allowing me to fire them remotely – especially useful when photographing the first dance to avoid wires trailing in a crowded room).

✓ Extension power leads.

*Having a professional appearance helps you to be treated as a professional on the day.*

*A few days before a wedding it is important to check your equipment thoroughly:*

✓ *Load fully charged batteries in your cameras and flash guns.*

✓ *Format your memory cards (it is not enough to simply delete images from your memory cards. Reformatting them will remove any data completely and prolong the life of the card).*

✓ *Make sure your memory cards are numbered and put into a secure wallet in sequence. This sequence needs to be adhered to when shooting so that you know at all times how much you have shot and, more importantly, how much memory you have left.*

✓ *Check that your camera's chip is clean. You may check the chip by opening up the aperture and firing the camera at a light source or white wall (you will need to put the camera into manual focus mode as the autofocus will not have anything to latch on to). Any dust on your camera's chip will show up in the image. You may remove dust by blowing gently with a blower (do not touch the chip with the brush of a blower brush or use compressed air as moisture can be propelled out with the air, which would permanently damage the sensitive chip). If the dust does not move with air alone, then have the chip professionally cleaned at a recommended camera repair centre.*

✓ *Pack your bag carefully, making sure you know where everything is.*

✓ *Lay out and iron your clothes. Having a professional appearance helps you to be treated as a professional on the day.*

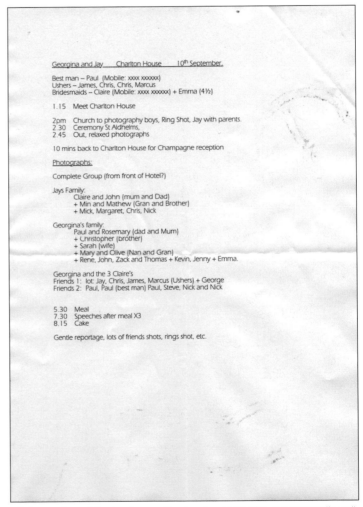

Before each wedding I write myself a shooting script (this one is typically well-thumbed). I always include timings for the day, planned photographs (along with the names of group members) and mobile numbers for members of the wedding party just in case things don't go to plan.

## Getting to Know Your Client

*How you deal with your clients at your first contact will determine how they perceive you as a person and a photographer. From the first meeting to the pre-wedding shoot, being relaxed, friendly and organised will help you to gain their trust.*

*At your first client meeting, it is important to put the couple at ease. Bringing them into a warm, clean environment and inviting them to sit comfortably will enhance the ambience. If you are working out of a studio or from home, it is equally important to have a quiet, relaxed meeting area, even if it is your dining room table or a large coffee table in the lounge. Before bringing out show albums, try to establish a rapport, as this will help clients to feel relaxed and familiar in your company.*

*Nikon D2x, 70-200mm f/2.8 lens, ISO 640, 1/160sec at f/2.8*

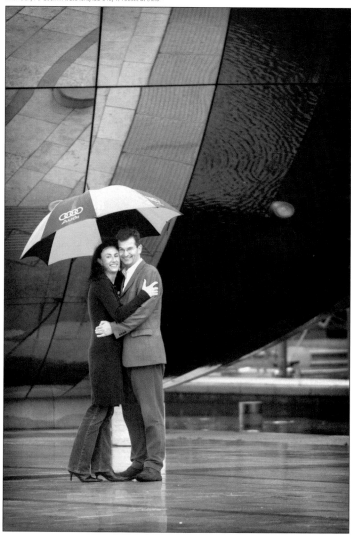

*Nikon D2x, 70-200mm f/2.8 lens, ISO 640, 1/160sec at f/2.8*

In poor weather I choose a city location over a rural one when doing location portraits, such as in these engagement shots. You may use architectural features as backgrounds or to shelter under in rain. You can also nip into a café or restaurant if all else fails!

From the first contact, establish where the wedding is to be held, and whether the ceremony and reception are at the same venue. By asking about entertainment, menus, expected guest numbers and how they imagine the day to go, you will gain valuable insights. Remember, each wedding is different and each couple have different expectations and priorities. Don't forget to take the opportunity to enquire how they heard about you, as this will help you to evaluate your advertising.

*When you show your work, make sure it is varied. Note down the things that they say, whether it is their personal tastes or the images in your portfolio they respond to. Negative responses are as important as the positive; these feelings say a lot about people and will help you to angle your photography to their taste. You, for example, may find a tumble-down wall full of old world charm, but your client may prefer something much more slick and modern. Ask questions that encourage responses. By asking the couple to describe their venue, you will gain both a mental image of the place and an insight into their characters. It is important to learn to read your clients' personalities.*

*By offering a pre-wedding shoot, you will not only assure the couple of your photographic skill but also gain an extra meeting in which to deepen your relationship with them. This shoot will help them to feel comfortable with the camera and will give you the opportunity to discuss the photography on their wedding day. It is good practice (but not always practical) to take the pre-wedding shots at the venue itself. If the weather is against you or distances too great, then you must choose another location. Consider using a local park or beauty spot or even a cityscape as a backdrop.*

*It is important to learn to read your clients' personalities.*

On this wedding day, we chose to stop off en-route to the reception. After shooting some portraits, I walked back to the car ahead of the couple. This gave them a little bit of precious time alone and allowed me to capture some very natural observed images with a long lens. The hazy summer sunshine enhances the romantic feel of the image.

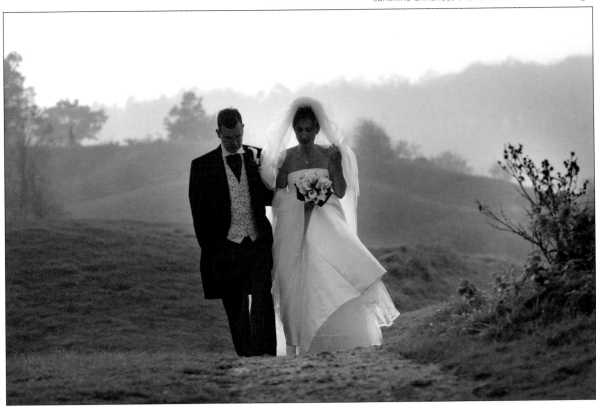

*Nikon D2x, 70-200mm f/2.8 lens, ISO 200, 1/1000sec at f/4*

## Know Your Territory

*By far the greatest challenge to the wedding photographer is to interpret each wedding as a unique event. Creating images that not only use your surroundings to their full advantage but also allow your clients to express their personalities is a talent indeed. This challenge is made easier by thinking ahead and careful planning.*

*Each occasion is an opportunity to create something new and exciting.*

*When you have been booked for a wedding, the next stage is to plan the photography. Even when you have photographed a wedding at the venue before, each occasion should be treated as an opportunity to create something new and exciting. First you should do some research. Visiting the venue will give you a head start on the day, and you may be surprised what you find around a corner. When scouting the venue, you should think about both outdoor and indoor locations, and about how and where you will work if the weather is against you.*

I was able to create all of the very different looking images on these pages within a few hundred metres of the reception venue. Looking for inspired backgrounds, I took a short walk to the city dock, but also found the highly coloured graffiti below.

*Nikon D2x, 28-70mm lens, ISO 250, 1/2000sec at f/6.3*

*Nikon D2x, 28-70mm lens, ISO 250, 1/2000sec at f/6.3*

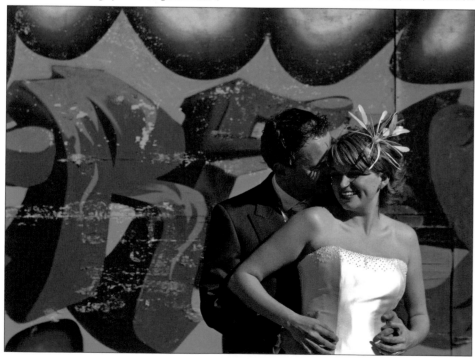

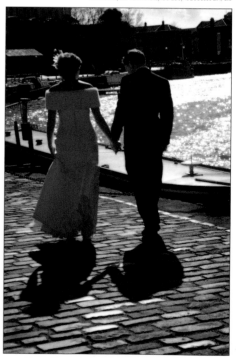

*Nikon D2x,*
*28-70mm lens,*
*ISO 800,*
*1/45sec at f/3.5*

Finding interior areas that are naturally illuminated will give you places to exploit in poor weather. In this shot, a large window gives soft natural light whilst the use of the mirror increases the image's depth.

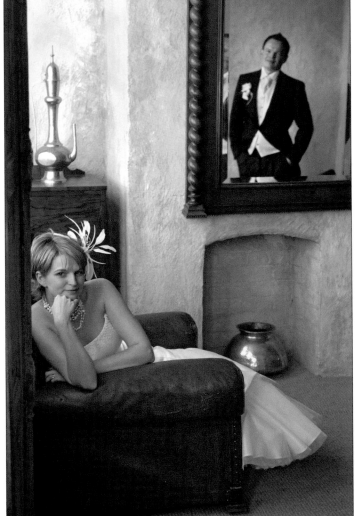

Taking portraits of the bride and groom away from the guests will allow the couple to relax without others looking on. If you are stopping off en-route to the reception, make sure that you have planned it in advance, and there is plenty of time to return and take the other shots you need before the guests are called for the wedding breakfast.

*Nikon D2x,*
*28-70mm lens,*
*ISO 500,*
*1/80sec at f/4*

## *Difficult Venues*

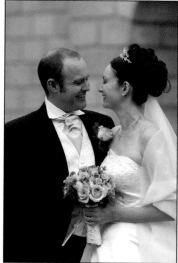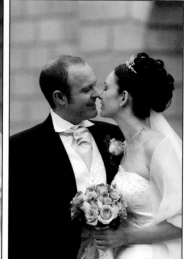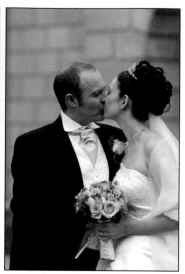

*Nikon D2x,
80–200mm f/2.8 lens,
ISO 200,
1/2000sec at f/4*

Using a long lens and a wide aperture gives a shallow depth of field that helps to isolate the subject from the background.

**Not all venues are graced with beautiful vistas. All too often a small church spills out onto a busy and untidy street, or the only space to take photographs is squeezed between a rubbish bin and some parked cars.**

*It is at times like this when your ingenuity and creative talents will come into their own. You must be able to quickly assess the situation and think on your feet. A lazy photographer will bemoan the lack of surroundings, blame the 'bad' venue and produce poor images. It is this photographer who will lose both revenue from reprint orders and recommendations by those attending the wedding.*

*When you are working in a challenging area, you need to find ways of minimising the background. By coming in close you are able to crop out much of the background in camera. Choosing a shallow depth of field will blow the background out of focus so minimising any unwanted detail. When shooting digitally, you may remove objects or crop the image later in Photoshop; but you will save yourself hours of work by being disciplined and creating the best possible image in camera. Remember that when you crop an image in Photoshop, you are relying on fewer pixels so reducing the size and quality of the final image.*

*If you are disciplined when you are shooting, you will save hours of work on the computer.*

Where the light is behind your subject, try using a little fill in flash to open up the shadow areas. In this shot, the flash was kept two stops below the ambient light reading, just enough to bring some detail into the shadows, while retaining a natural look.

*Nikon D2x, 28-70mm lens, ISO 640, 1/60sec at f/3.5 ,Nikon SB800DX Speedlight with an exposure compensation of -2 stops*

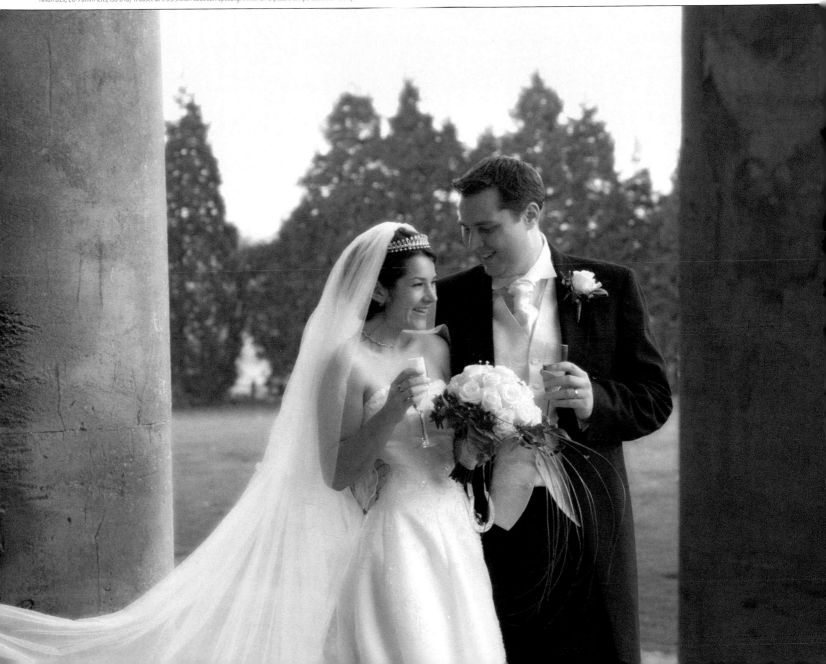

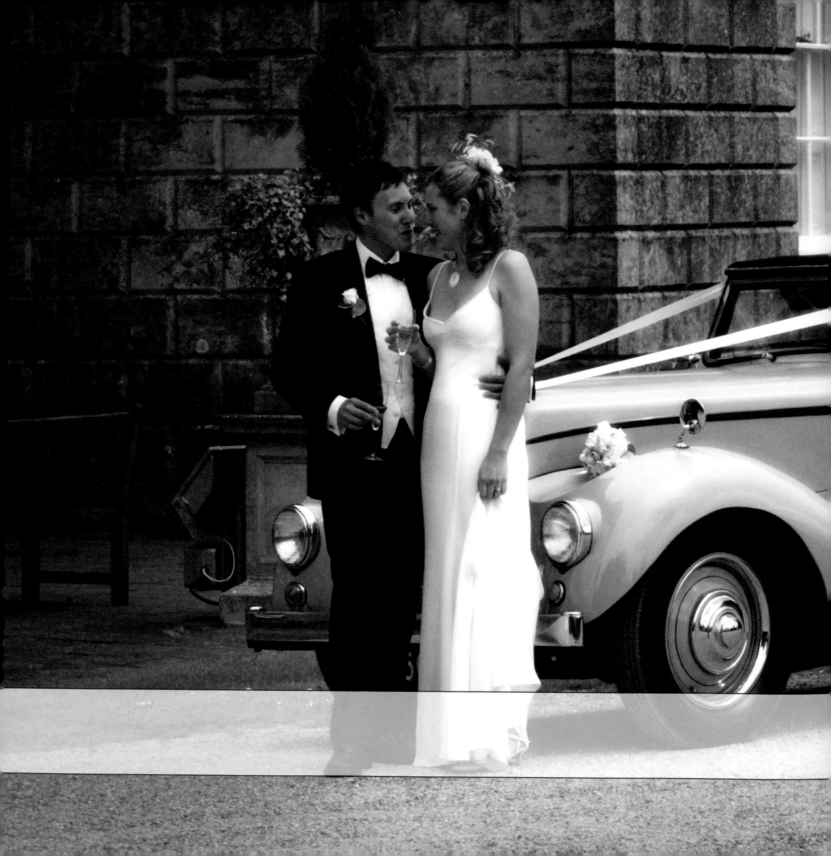

**Chapter 2** *Styling and Using Light*

## Directing Natural Looking Portraits

Always keep a keen eye on the lighting as you move around the wedding and reception venues. As soon as you notice a pool of soft natural light, make a mental note and invite some participants to this area when you get a moment later.

**The key to creating natural looking images is to set up a situation and encourage your subjects to interact. When people are relaxed and really enjoying themselves it shows.**

It is the wedding photographer's job to create a representation of the day that captures its natural flow. Most couples no longer want stiff, over-posed images, but expect to have much more fun and spontaneity on their wedding day. They also now prefer to enjoy the event with as little disruption as possible, instead of much of the day being dedicated to photography.

This may seem at odds with your role as photographer, as usually you will still have a list of requested shots to deliver. If you manage to do so in an unobtrusive manner, you will be remembered and recommended, not only by the bride and groom but also by their families and guests. The best advertising is recommendation, as a person who has had a positive experience is listened to by others.

Shooting digitally has many advantages in wedding photography. Not least is the camera's ability to shoot in low light levels, which means you can be close to the action and make images discreetly without flash. A bride may feel tense and apprehensive before the wedding and having cameras flashing around her will just add to her nerves. A photographer who can work in a quiet, unobtrusive way will put her at ease and the resulting shots will be relaxed and natural.

When you are able to shoot without flash, your images will appear deeper with richer shadows. On-camera flash flattens the image by wiping away all the soft modelling that results from the angle of the light source. If a little flash needs to be added, try bouncing some in

*Nikon D2x, 28-70mm f/2.8 lens, ISO 800, 1/60sec at f/4.5*

from a wall or ceiling. Remember that the flash will reflect the colour of the wall onto your subject, so, to keep flesh tones looking natural, it is important to use a white or neutral surface. This is not a problem if you are planning on converting these images to black and white (see Chapter Six 'The Digital Darkroom').

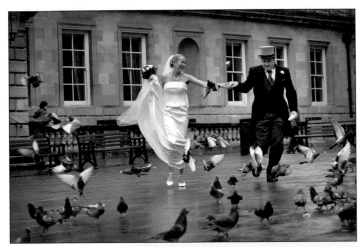

*A photographer who can work in a quiet, unobtrusive way will put the bride at ease leading to relaxed and natural shots.*

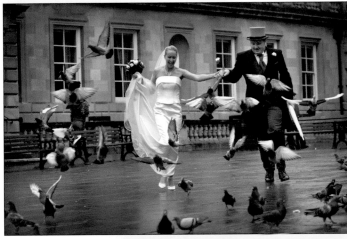

*Nikon D2x,*
*28-70mm f/2.8 lens,*
*ISO 400,*
*1/800sec at f/2.8*

The wet paving slabs help to create the atmosphere in this series. Rain reflects light upwards creating reflections that increase the mood in otherwise flat overcast conditions. Although the shot was directed, the laughter was real as the couple ran through pigeons on a wet Saturday afternoon. Creating an air of fun and a disregard for conventions in your work will earn you a reputation as being an imaginative and individual photographer.

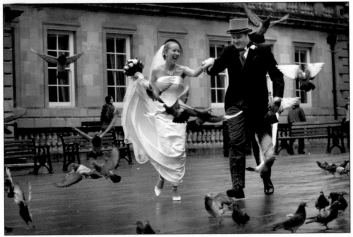

# The Bride Before the Wedding

Nikon D2x,
28-70mm f/2.8 lens,
ISO 400,
1/200sec at f/3.5

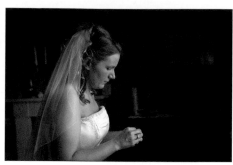

*Placing the bride by a window and shooting at an angle will make the most of the naturally soft light.*

**When photographing the bride before the wedding, I try to make natural images as things happen. Planning the time you expect to be with the bride and arriving promptly is important to keep her secure in knowledge that the day will pass off without a hitch.**

*Asking her to be ready save for the finishing touches (dress, jewellery, tiara, shoes etc) gives a focus to your images. Not only can you shoot these as detail shots, but also your bride has something to do to take her attention away from the camera. Many photographers shoot the bride as she puts on the dress. At this point you must judge your client carefully; if you think having the photographer in the room would make her uncomfortable, then suggest that she slips into her dress with just her bridesmaids or mother to help. Make sure they call you into the room just before the back of the dress is fastened up. You will then get the feel of her dressing without needing to be present.*

*If you take your pictures in an uncluttered room or against a plain wall, it allows the eye to see the subject without being distracted by pattern or colour. Once the bride is in her dress, you may wish to invite her towards a window to put on her jewellery or check her make-up. Placing her before the window (but out of direct sun) and shooting at an angle will make the most of the naturally soft reflected light. If your bride has her attention on what she is doing, your images will have a gentle and reflective quality.*

*Finding a plain area can be a challenge. In the shots on page 29 most of the walls were busy and space was tight, so I had to move the bed to allow for full-length shots. Don't be afraid to ask if you can move furniture or pictures if it will allow you to get the shot you need.*

*In many homes and hotel rooms you will find that wallpaper, pictures and ornaments make fussy backgrounds. One way to minimise the background is to take your images close in, choosing soft natural light from a window to illuminate your subject whilst casting the rest of the room into shadow.*

Top left: Nikon D2x. 28-70mm f/2.8 lens, ISO 800, 1/30sec at f/4; bottom left: Nikon D2x, 28-70mm f/2.8 lens, ISO 800, 1/30sec at f/2.8; right: Nikon D2x, 28-70mm f/2.8 lens, ISO 800, 1/60sec at f/5

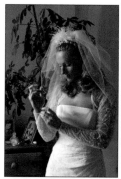

If you need move a piece of furniture it is as well to get permission first, as shifting an antique table with a wonky leg can be nerve wracking!

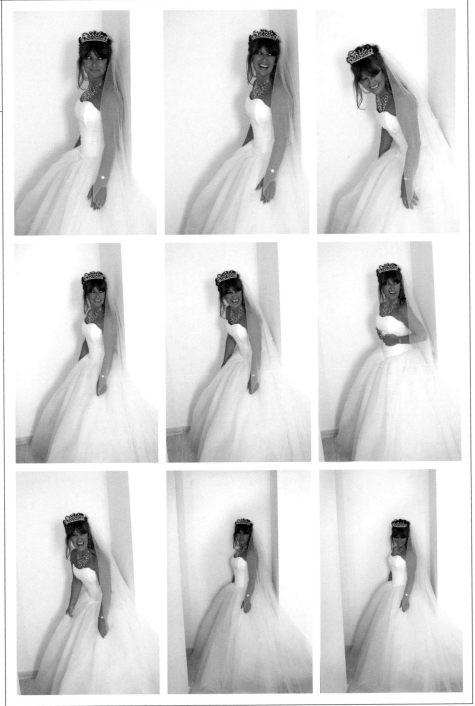

*Nikon D2x,*
*28-70mm f/2.8 lens,*
*ISO 400,*
*1/125sec at f/4*

The nine shots here were taken with a little flash bounced from the ceiling to supplement the natural light from a small window in the facing wall. Arranging images in a sequence can make a great page in the final album.

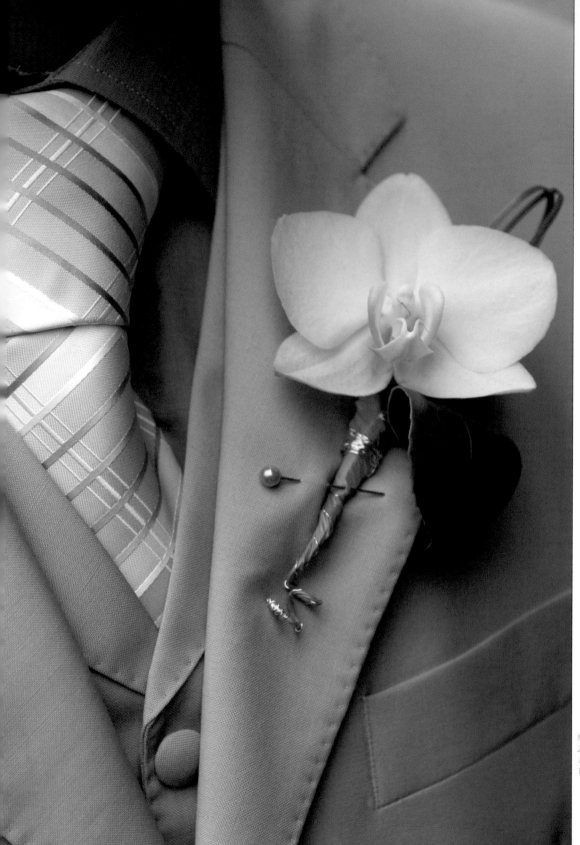

## The Groom

Nikon D2x,
28–70mm f/2.8 lens,
ISO 200,
1/350sec at f/4.5

**It is easy to focus on the bride before a wedding and overlook the groom. However, a good early portrait of the groom is an important shot among the first pages of a wedding album.**

*It is becoming increasingly popular for grooms to plan an activity before the wedding. This may involve a round of golf, or shooting, or just meeting friends for a drink in the bar. If you can be present, you may find the perfect opportunity to catch an off-guard moment when he really is relaxed and happy with close companions. This is also a time to photograph the best man trying to fix the groom's buttonhole, or to catch a quiet moment of contemplation.*

*Where there is not time to go to the groom as well as the bride before the wedding then try to arrive at the wedding venue a good 40 minutes before the ceremony. By getting there early you will have lots of time to photograph the venue, capture guests and be ready to photograph the groom and his party as they arrive.*

*Shooting the groom with his best man and ushers in front of the wedding venue ticks off two of the 'must have' shots. As well as establishing the outside view of the venue, you have taken one of the expected groups, thus leaving more time later in the day to explore your creativity in other ways.*

*Nikon D2x, 28-70mm f/2.8 lens, ISO 200, 1/200sec at f/3.5*

*Arrive at the venue in plenty of time to photograph the groom and his party arriving.*

*Left: Nikon D2x, 28-70mm f/2.8 lens, ISO 400, 1/125sec at f/3.5*
*Right: Nikon D2x, 28-70mm f/2.8 lens, ISO 400, 1/100sec at f/3.5*

# The Ceremony

*Shooting by available light is both softer and more intimate, so better for capturing the atmosphere of the building.*

*Nikon D2x, 28-70mm f/2.8 lens, ISO 800, 1/30sec at f/2.8*

*Nikon D2x, 28-70mm f/2.8 lens, ISO 800, 1/40sec at f/2.8*

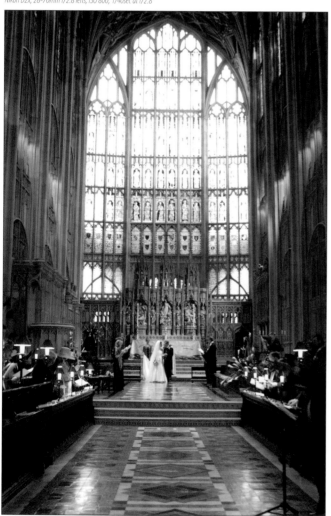

**There is no right or wrong way to photograph a ceremony. Each one is unique, offering very different opportunities to the photographer. Whereas in a church you may not be able to move from your allotted position, in an outdoor or garden ceremony you will be able to use a long lens and shoot from a distance, changing your position quietly and often to gain extra shots.**

*In some wedding venues, particularly churches, strict guidelines govern the way in which photography is conducted. Respecting rules and planning around these is important, as you do not want to put pressure on the couple or disrupt the proceedings (I have heard of photographers disregarding requests not to shoot during certain parts of the ceremony and being asked to leave the building!). But just because you are told that photographers are expected to remain in a certain place, it should not stop you from asking if you may shoot from somewhere else. If you are thoughtful, polite and always seek permission, you will find that even some of the strictest rules may be bent a little, and you may gain a much better position from which to shoot.*

*I like to choose a vantage point where I am facing the bride and groom with their guests behind. This allows me to capture their expressions as they change, as well as the tiny, intimate moments that are unique to this wedding. Having the bridal party or guests behind (but dropped out of focus) hints at the inclusive quality of the ceremony. A wedding, after all, is when a couple share a very personal exchange and their deep love for each other with their closest friends and family.*

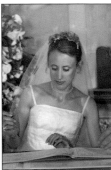

*Far Left:*
*Nikon 100,*
*28-70mm f/2.8 lens,*
*ISO 640,*
*1/50sec at f/4*

*Left:*
*Nikon D100,*
*28-70mm f/2.8 lens,*
*ISO 800,*
*1/50sec at f/4,*
*Nikon SB80DX Speedlight used with*
*an adjustment of -1.5 stops*

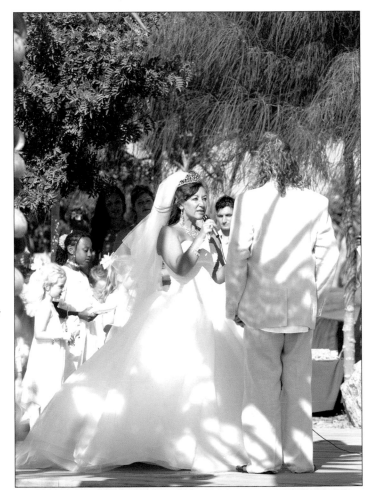

When shooting an indoor ceremony with low light levels, it is important to use a tripod to allow for slow exposures. Most venues will not allow flash at this point and, in any case, the use of flash and faster shutter speeds would cut down on the background light entering the lens, thereby creating a more two dimensional image. Shooting by available light is both softer and more intimate, so better for capturing the atmosphere of the building you are in.

The issue of low light levels does not present itself with an outdoor or garden wedding. Here your subjects are flooded with light and you can easily hand hold your camera with even the longest of lenses, so allowing you to create more spontaneous and varied images.

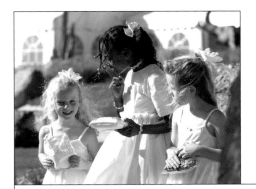

*Black & White Images:*
*Nikon D2x,*
*70-200mm f/2.8 lens,*
*ISO 100,*
*1/640sec at f/4*

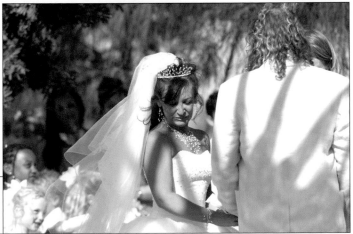

# During an outdoor ceremony it is easier to move around. This will let you capture shots you may otherwise miss such as an interaction between guests or young bridesmaids.

## A Sense of Place

**Creating images that have a strong sense of place will help to ground the final wedding album. If you are photographing a city wedding, allow city locations to feature in the images. The use of landmarks and recognisable places will give albums obvious points of reference, but you can be more subtle, as in the images on these pages by the photographer Joe Buissink.**

*In the photograph of the bride about to get into the car, for example. The city is allowed to creep into the background and gives a hint of the location, while the flag firmly places the image in America.*

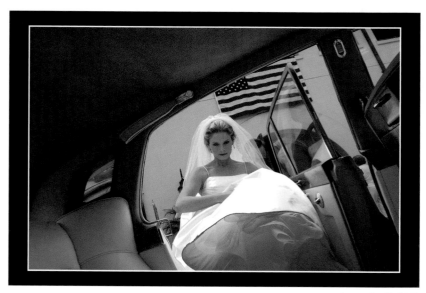

*Image courtesy of Joe Buissink*

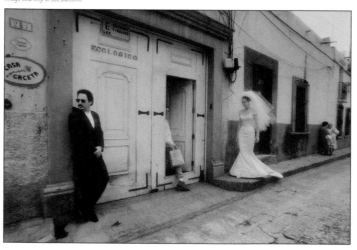

*Image courtesy of Joe Buissink*

*The street scene shows Joe's versatility and humour. Here he catches a 'decisive moment' as the bride and groom are about to be joined by an unsuspecting member of the public stepping out from a doorway. The image is evocative, warm and grainy; all these aspects help to build sub stories in the narrative of the shot.*

*Joe chooses to shoot his colour work digitally but his signature black and white images are taken on film. Once his film is processed, it is hand printed traditionally in the darkroom. His technicians take full advantage of darkroom processes as well as traditional toning such as selenium and copper to give the prints further depth and warmth. As hand printing in this way is very intuitive, no two prints will be exactly the same, giving a truly unique image each time.*

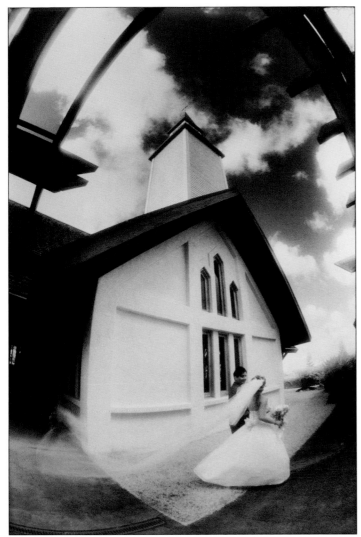

Image courtesy of Joe Buissink

*Images that have a strong sense of place will help to ground the final wedding album.*

Image courtesy of Joe Buissink

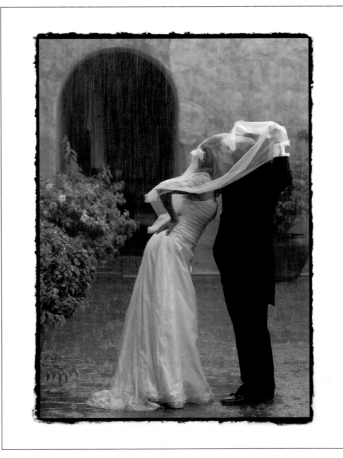

*The scene shot in the rain evokes the feeling you have at the moment a hot lazy afternoon breaks into a summer downpour. Joe Buissink's great skill as a photographer and his use of tone, texture and colour help to transport the viewer to the places in which his images are taken.*

## Capturing Pure Emotion

*If you are not getting great shots, it may just be that you are in the wrong position.*

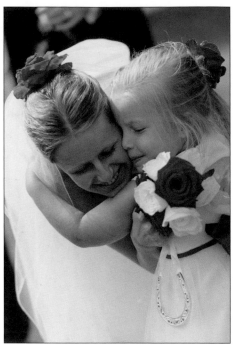

Canon EOS 1V, 24-70mm f/2.8 lens, Fuji Reala ISO 100, 1/500sec at f/4

Nikon D2x, 28-70mm f/2.8 lens, ISO 200, 1/200sec at f/4.5

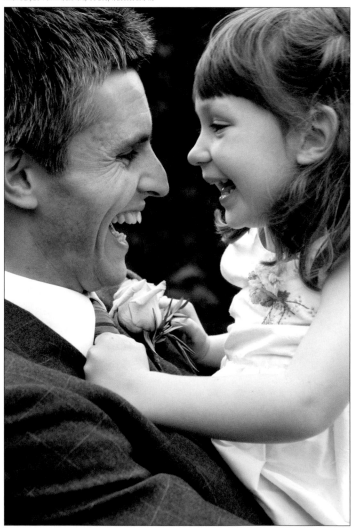

**Today's wedding photographer needs the ability to observe and capture the most fleeting moments of emotion. Keeping alert with your camera poised is paramount when taking observational shots. In a moment when you are off-guard you may miss beautiful, natural moments, which you can never restage.**

*Putting people at ease and the ability to melt into the background will allow you to move around freely. You must try to pre-empt the action so you can get into the best position to catch what is about to happen. Try to stay aware of the direction of the light at all times. If there is bright sunshine that would bleach out the bride's dress as she emerges from the church, then crouch down to one side so she is backlit as she comes out. If you are not getting great shots, it may just be because you are in the wrong position.*

The photographer who constantly directs the action may create great formal or classical images, but may miss the small exchanges that hint at the true connection between the individuals. Weddings are full of laughter, delight and tender feelings. If you are able to weave these into the story that you are creating, the final album will reflect the true emotion of the event and be treasured for generations.

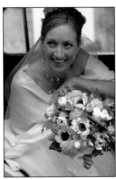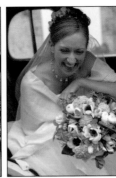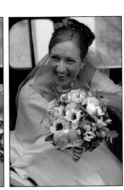

*Nikon D2x,
28-70mm f/2.8 lens,
ISO 400,
1/60sec at f/4.2*

*Nikon D2x, 28-70mm f/2.8 lens, ISO 100, 1/200sec at f/6.3*

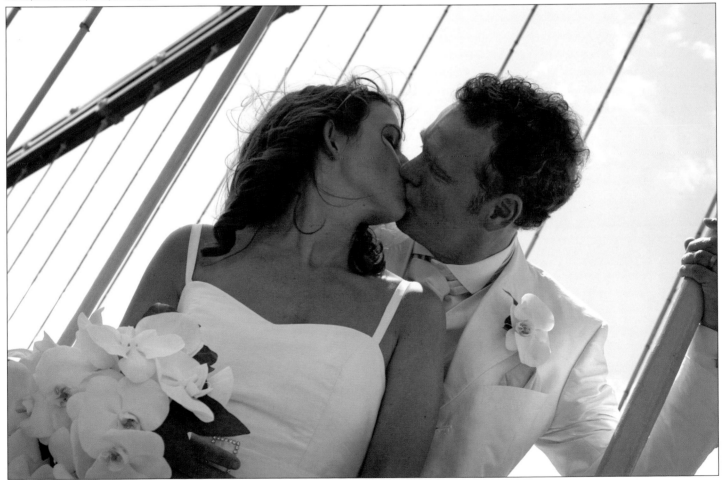

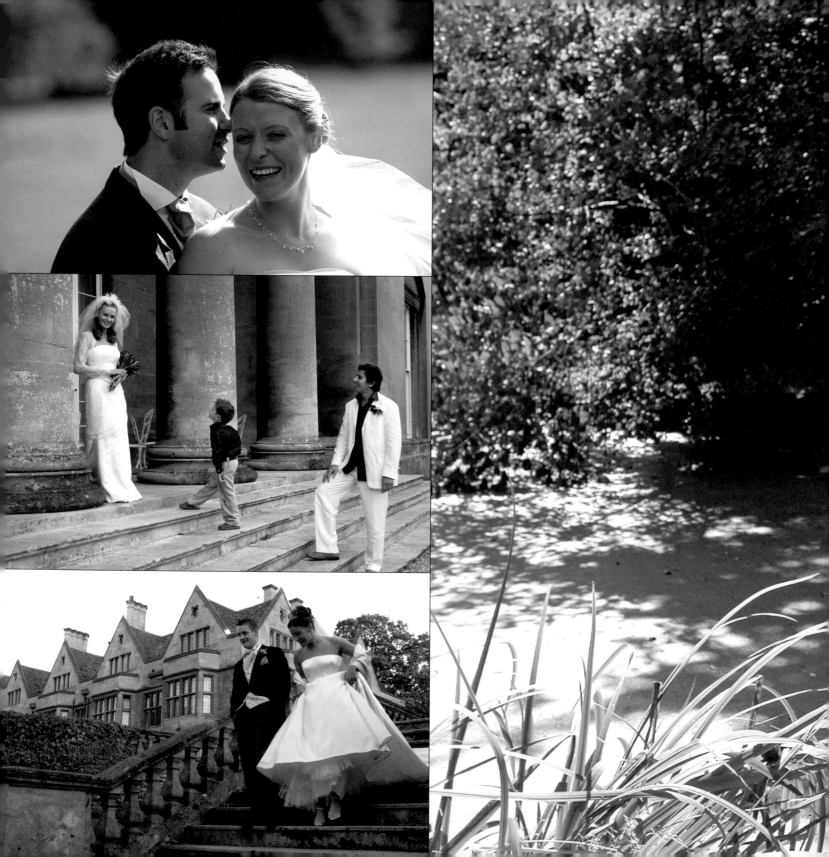

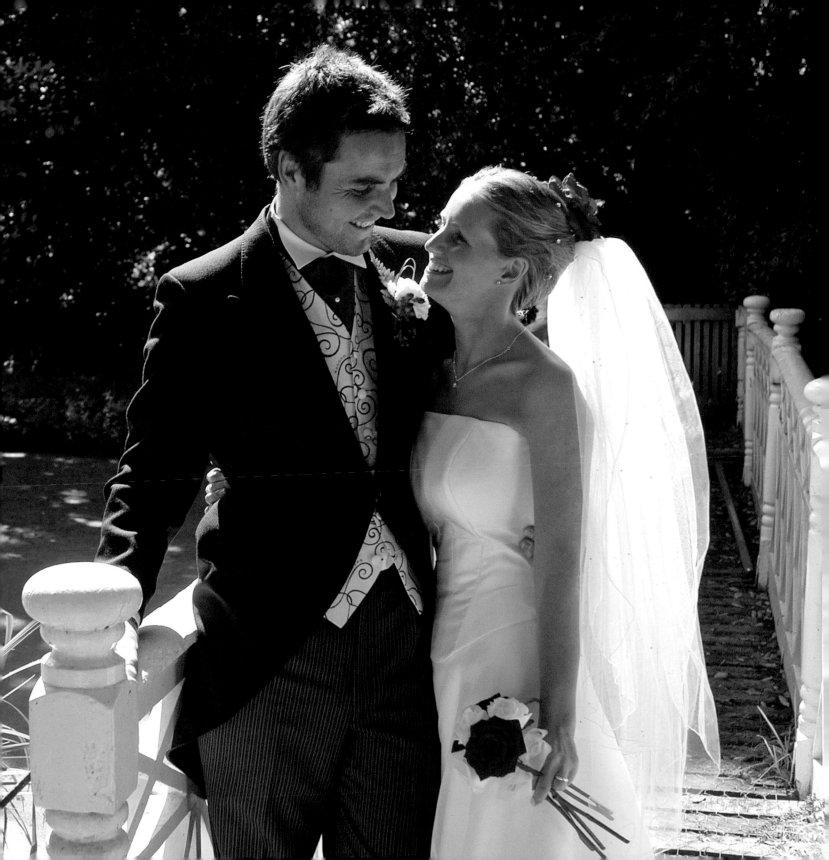

## Using Your Surroundings

Strong graphic lines or bold architectural features can make the perfect backdrop for portraits. By encouraging the couple to interact, the resulting portraits have a natural, spontaneous feel.

*Thinking on your feet and being able to react to your surroundings are skills that are vital to the digital wedding photographer. One of the greatest challenges is to respond to your environment in a new, fresh and exciting way at each wedding you attend. Remember that it is not only your location that you need to work with, but the lighting conditions, too, dictate the mood of the final images. You should strive to get to know your equipment so that you instinctively know how it will react to bright sunlight, for example, or the optimum depth of field needed to sink ugly backgrounds out of focus.*

If you are photographing in a city location with no gardens, then you need the ability to visualise alternative and creative backgrounds. Urban environments offer huge scope for this and strong architectural features, or just using the cityscape, can be as good or better than popular 'wedding' settings such as bridges, walkways or parks.

Driving to a location with the bride and groom will allow you to have time alone with them to make some romantic portraits. It is at this point in the day that your forethought and creativity will pay off. When choosing a location it is a good idea to discuss the place with the couple beforehand. They may find your ideas strange at first, but if you help them to visualise the final image, many couples will become infected with your enthusiasm and will react well to your chosen environment.

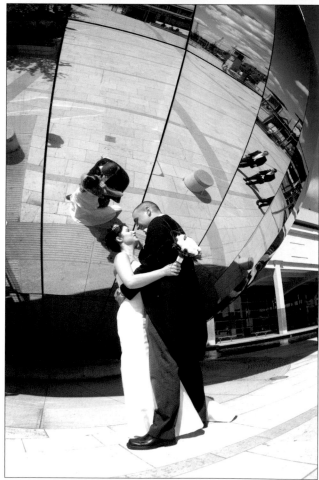

*Clockwise from top left:*
*Nikon D100, 28-70mm f/2.8 lens, ISO 200, 1/750sec at f/5.*
*Nikon D100, 28-70mm f/2.8 lens, ISO 200, 1/500sec at f/5.*
*Nikon D2x, 15mm f/2.8 180° fisheye lens, ISO 100, 1/3000sec at f/4.*

*Nikon D100,
28-70mm f/2.8 lens,
ISO 400,
1/640sec at f/4.5*

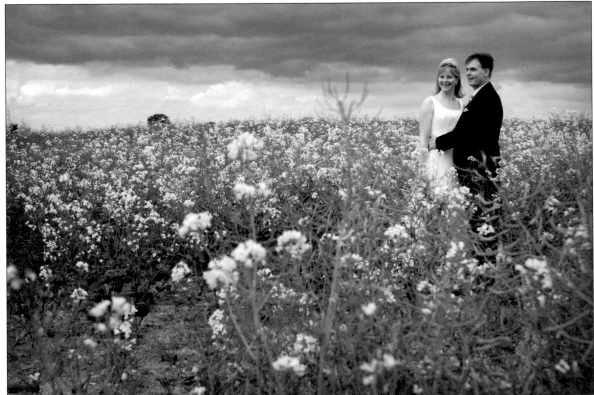

The strong side light of late afternoon autumn sunshine adds drama to the image of the groom and ushers. Contrasting is the portrait of the couple in a countryside location with soft flat lighting from an overcast sky. The clouds were brooding, but were a little pale in the original digital file. The sky was darkened in Photoshop to enhance the mood in the final image.

*Nikon D100, 28-70mm f/2.8 lens, ISO 200, 1/500sec at f/4*

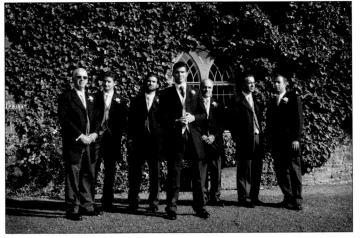

*If you discuss your ideas with the couple and help them to visualise the image, they will usually adopt your enthusiasm.*

*Try to stay aware of changing weather. In many places it can be unpredictable at any time of year with cloud cover masking the strong light you are working with or a sudden shower taking you by surprise. This is when it is crucial to be adaptable and ready for all eventualities. Rain should not mean disaster for wedding photography; instead photograph the bride and groom as they run for cover, or the laughter that is generated as they huddle under an umbrella. You may find architectural features such as ledges or doorways to hide under and still make images in beautiful, soft, filtered light.*

## Working in the Rain and Quick Lighting Setups

*Most couples will risk getting a little wet to create some memorable images.*

Nikon D2x, 28-70mm f/2.8 lens, ISO 400, 1/500sec at f/4

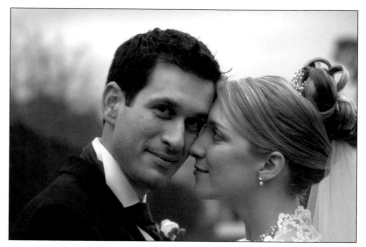

Nikon D2x, 70-200mm f/2.8 lens, ISO 400, 1/640sec at f/2.8,

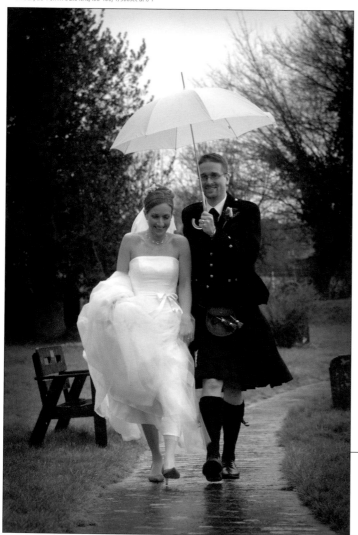

*A creative wedding photographer will not be daunted by poor weather. Shots taken in the wind or rain can be full of emotion, passion and excitement. Being prepared for all weathers helps you to cope with a sudden change. It is a good idea to invest in some large white golf umbrellas for the boot of your car (remember that coloured umbrellas will create ugly colour castes in flesh tones). Try to find umbrellas that do not have logos on them as these will detract from your images.*

*When I am shooting a wedding on a wet day, I still try to take as many shots as possible with natural light. When I ask them, most couples will venture out under umbrellas or risk getting a little wet to create some memorable images. If the bride or groom is uncomfortable by the idea of rain, then I use light coming in from doorways or windows to illuminate my subjects.*

Even simple shots taken outdoors in bad weather will add a different dimension to the wedding album. Wet ground has a reflective quality, which will add drama to your shot.

*Winter weddings also offer challenging conditions as the light fails early in the day. I carry studio flash heads in the boot of my car and use them when it is too wet, stormy or dark to take many shots outdoors. A two light set up is both quick and effective for interiors. First I look for an area that is out of the way and will not have too many guests wondering through. Then I quickly set up my lights, metering them carefully so that, when I invite my subjects in, I know what camera settings are needed. The main light will be softened by using a soft box or bounced from a white umbrella. Where shadow areas sink into the background, the backlight creates 'lift'. This is especially useful when you are working in a venue with wood panelling or deep coloured walls.*

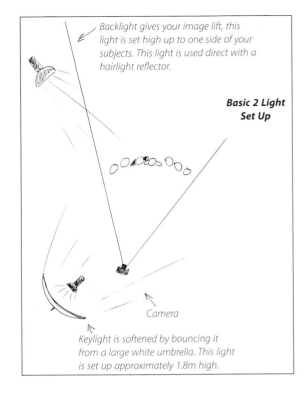

*Backlight gives your image lift, this light is set high up to one side of your subjects. This light is used direct with a hairlight reflector.*

**Basic 2 Light Set Up**

*Camera*

*Keylight is softened by bouncing it from a large white umbrella. This light is set up approximately 1.8m high.*

In this shot, there was not enough space to place my backlight behind and at an angle to the group so I placed it looking over the edge of a balcony above. The light glanced across the heads and the shoulders of the group members, giving them a little separation from the background.

*Nikon D2x, 28-70mm f/2.8 lens, ISO 400, 1/60sec at f/7.1*

*Nikon D2x, 28-70mm f/2.8 lens, ISO 400, 1/60sec at f/8*

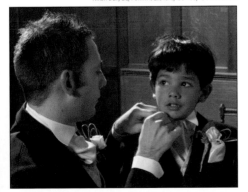

Here the power of the backlight was turned up to increase the drama and maximise the three dimensional effect. This method of a strong backlighting can be very effective when shooting the first dance (see pages 90-91).

## Photographing Informal Groups

**Even when photographing in a documentary or reportage style, most clients will still expect a certain number of group shots, but they will want these to be fun, spontaneous and informal. While many can be taken off-the-cuff by observing the natural groupings that occur, others must be directed.**

*To make a grouping less formal, try gathering people together then ask them to huddle close. Turn them slightly inwards as this will encourage interaction. You could ask your subjects to think about anything that was funny in the lead-up to the wedding. If all else fails, just ask them all to laugh out loud on the count of three. This may cause a little embarrassment at first, but wonderful natural laughter usually follows.*

*Giving directions to the participants could be as simple as asking them to talk closely and walk away from you arm in arm, or run towards you hand in hand. Switching from a standard to a telephoto lens will change the look of the image, whilst getting in close with*

*If all else fails, just ask the group to laugh out loud on the count of three.*

Nikon D2x, 28-70mm f/2.8 lens, ISO 200, 1/125sec at f/5.6

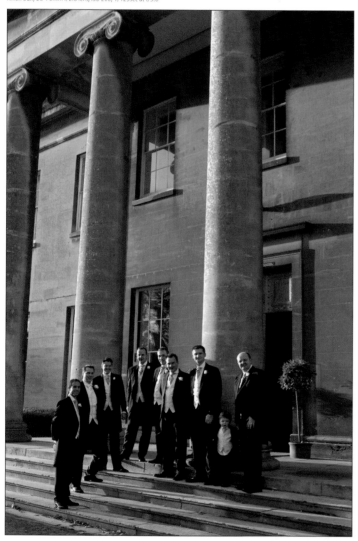

Nikon 2x, 28-70mm f/2.8 lens, ISO 200, 1/250sec at f/4

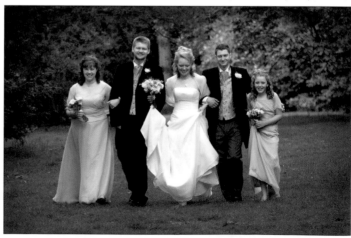

*a wide angle lens will bring in the surroundings and create a more photojournalistic look.*

*Nearly every wedding demands a few formal images. Although you should try to carry these out in an efficient and fluid manner, it is important to keep an element of fun in the proceedings. When photographing the complete wedding party, I prefer the guests to have a glass in hand. A simple request to raise their glasses for the bride and groom, or to make a loud cheer on the count of three, ensures that you have everyone's attention.*

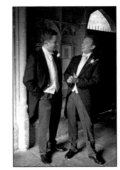

Nikon D2x, 28-70mm f/2.8 lens, ISO 640, 1/60sec at f3.5

Nikon D100, 28-70mm f/2.8 lens, ISO 200, 1/1000 f4

Nikon 2x, 15mm f2.8 fisheye lens, ISO 400, 1/250sec at f/8

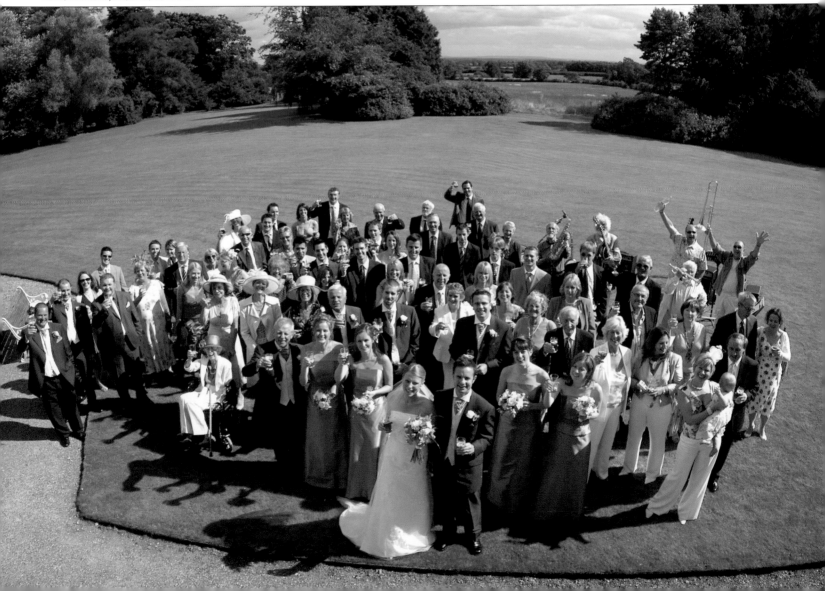

## Structuring Formal Group Shots

Back lighting group shots means that your subjects will not be squinting into the sun. You also achieve a pleasing halo effect as the light hits the head and shoulders of your subjects and gives separation from the background. Always use a good lens hood when shooting into the sun. Be especially careful in late afternoon or when the sun is low, as any light hitting your lens will cause flare and may ruin your shot.

*When photographing family groups, you should work from a list prepared in advance with the couple. It is important to operate in an ordered and methodical way so that these shots may be carried out with minimum fuss and disruption to the day.*

*Remember, if you do too many groups it will use up a considerable amount of time. Try to limit the number of groups to between six and ten. If the couple request more, you could suggest that some are taken later in a more informal way.*

*A quick method to begin is by arranging the couple so that they face in towards each other a little, but with their outer foot pointing towards the camera. Making sure the groom is marginally behind the bride, ask him to bring his hands towards her waist. Linked in this way, the couple will naturally hold the position in which they are standing. You can now start building the family around them. This is the plan I usually follow:*

*Nikon D2x,
28-70mm f/2.8 lens,
ISO 200,
1/125sec at f/6.3*

*Nikon D100,
28-70mm f/2.8 lens,
ISO 320,
1/400sec at f/5*

*Nikon D2x, 28-70mm f/2.8 lens, ISO 250, 1/250sec at f/5.6*

1. *Start with the bride's parents.*
2. *Ask any brothers or sisters to join.*
3. *Then add their partners and children (if they have any) or any other significant family member (such as grandparents).*
4. *Invite the remaining outer family to join (aunts, uncles, cousins etc).*
5. *Asking your couple and the brides parents to remain exactly as they are, you can dismiss the group and invite the groom's parents to join them. A photograph of the couple with both sets of parents is a popular shot.*
6. *Now you must do the same with the groom's family, beginning with the bride and groom and the groom's parents.*
7. *Add any siblings.*
8. *Add siblings' families or other significant family members if requested.*
9. *And finally the remaining family.*

*Always work out the group shots in advance with the couple. I make sure that I know the names of each group member and their relationship to the bride or groom. This helps me to find people quickly if somebody is missing. You should find that this model fits most families but you must stay flexible and be prepared to think on your feet if any of the groups suddenly change. Remember many modern families are a little more complicated than the above example!*

*Try to limit the number of groups to between six and ten.*

Remember that just because 10 group shots have been requested, it does not mean that they should all look the same. If a shot is listed as being members of the stag party, then you can guess that they may appreciate a bit of fun being injected into the image. In this shot, we imagined a scenario where the groom was a Mafia don in a film.

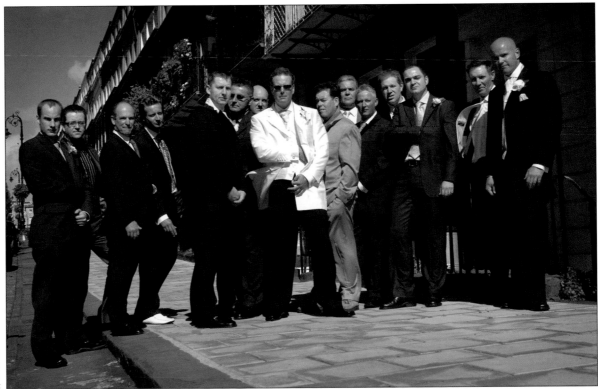

*Nikon D2x,*
*Nikon AFS 28-70 f2.8 lens,*
*ISO 200,*
*1/1250 at f/4.5*

Canon EOS 1V, 16-35 mm f/2.8 lens, Fuji Reala ISO 100 (scanned and processed in Photoshop), 1/125sec at f/5.6

## Children

*The family will treasure the images you take for years.*

Children play a special role at weddings. Their very presence brings people together across generations. They generate noise, fun, excitement; they become a focus as adults mill around. Photographs taken of them at a wedding not only show how cute they looked dressed up for the occasion, but also become historical records about their development. How a child plays or reacts to a situation speaks volumes about this point in his or her life - the family will treasure the images you take for years.

To gain natural images of children you must train yourself in the art of observation, have your camera poised at all times and work quickly without drawing attention to yourself. Every photographer has experienced seeing something delightful occurring, bringing his camera to his eye just too late, and missing the moment. As soon as a child realises the camera is trained on them, they will pose, tilt their head to one side and pull a grin, or worse, run away and hide. A long lens can be helpful as you may observe from a distance and be less conspicuous.

When thinking in terms of building your photographic business, taking great shots of children at a wedding shows the family and guests that you are an accomplished portrait photographer. As 'lifestlye' portraiture is becoming increasingly popular, you will build a reputation as more than (just) a wedding photographer. By getting referrals from wedding clients and guests, your business and experience will grow quickly.

*Nikon D100, 28-70mm f/2.8 lens, ISO 250, 1/125sec at f/4*

# Children
will often go off in search of their own entertainment during a wedding. Keeping a keen eye on what they are up to allows you to catch some great moments that otherwise pass off unseen.

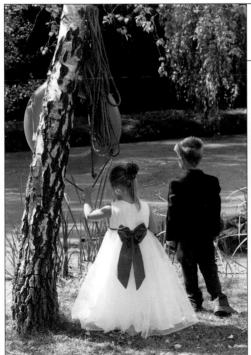

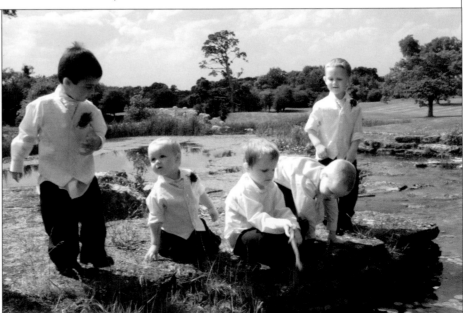

*Canon EOS 1V, 70-200mm f/2.8 lens, Fuji Reala 100 ISO (scanned and processed in Photoshop), 1/500sec at f/4*

*Nikon D100, 28-70mm f/2.8 lens, ISO 200, 1/640sec at f/4.5*

## The Evening

**As the shadows lengthen and the evening approaches, you may relax into taking final portraits of the bride and groom and last shots of the guests as they make their way into the wedding breakfast. At this point in a wedding the mood is usually jovial and warm. It is a great time to catch groups of guests laughing and joking or sharing stories.**

*Many photographers bring their coverage to a close as the guests take their places for the meal. If you are photographing the evening events, there is usually a line up (for the guests to formally greet the bride, groom, parents, best man and bridesmaids), then the meal, cake cutting, dessert, then speeches. The first dance usually brings everyone together and the evening may continue with a finger buffet and dancing, often with extra guests invited. Be aware that the sequence of events often varies and many weddings overrun.*

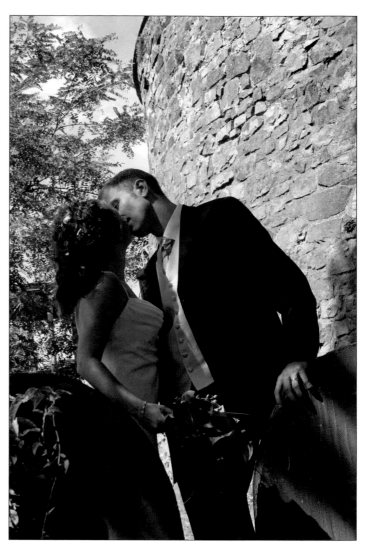

*Nikon D100, 28-70mm f/2.8 lens, ISO 400, 1/250sec at f/5.6*

*Nikon D2x, 28-70mm f/2.8 lens, ISO 400, 1/500sec at f/4*     *Nikon D2x, 28-70mm f/2.8 lens, ISO 640, 1/50sec at f/4*

 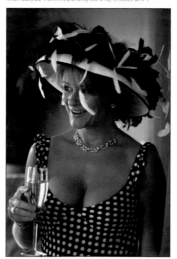

*This is a great time to catch groups of guests laughing and joking.*

*A dedicated flashgun and a long lens are useful when photographing the speeches as you may be indoors and it will often be dark at this point. By using higher ISO settings and slower shutter speeds (whilst being careful to avoid camera shake) you will expose for more of the ambient light in the room so maximising the feeling of depth in your shots.*

Trying to do something new at each wedding that you attend will make your photography stand out. Why not ask the venue staff to move the cake from a dark corner to the centre of the room in front of a window? When the bride and groom come to cut the cake, position them facing the window and invite their guests to gather in close. Having your back to the window ensures that the couple and guests are flooded with natural light. You may also wish to stand on a chair to raise your point of view or shoot from low down to make the cake dominant in the frame.

*Nikon D100, 19-35mm f/3.5-4.5 lens, ISO 800, 1/40sec at f/3.5*

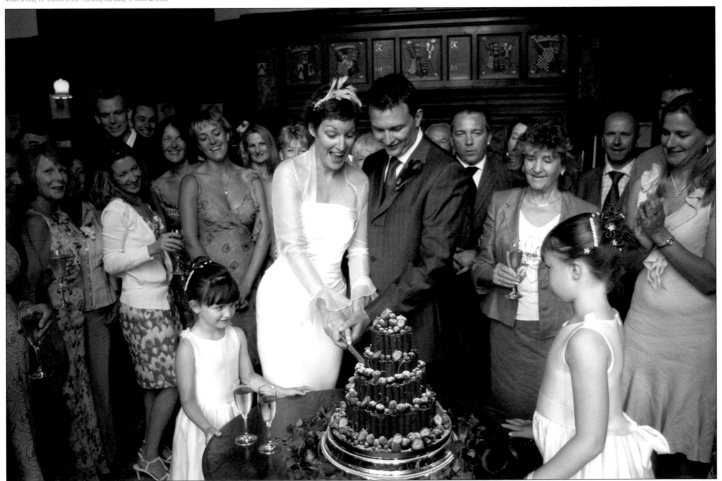

**Chapter 3** *Photographing Details and Close Ups*

## Picking Out Important Details

Nikon D2x,
28-70mm f/2.8 lens,
ISO 200,
1/800sec at f/4.5

> *When shooting details, consider carefully how you might use them in the album.*

Nikon D2x,
28-70mm f/2.8 lens,
ISO 200,
1/800sec at f/4.5

**A wedding day may be viewed as a succession of important details. Each object, from car to fabric, will have been carefully chosen. Each texture and tone selected for compatibility or contrast. Each morsel of food designed to delight and engage the guests. Each sound and smell is there to enhance the experience of the day.**

*So much painstaking planning and attention to playful detail goes into a wedding. Most of these things will merge into the general memories of the day, after being eaten, drunk or (in the case of the bouquet) thrown. If you as photographer can document the detail, you will enhance the memories and keep them alive far beyond the day itself.*

Nikon D2x,
28-70mm f/2.8 lens,
ISO 200,
1/800sec at f/4.5

*When you are photographing close ups, it is important to keep their end use in mind. They may rarely be ordered as reprints, but fulfil an important role in the final album. Try to shoot so that they may work together on a page, or throw a detail shot into a sequence of wider shots where it may help in the final design.*

Nikon D2x,
28-70mm f/2.8 lens,
ISO 400,
1/90sec at f/5

Nikon D2x,
28-70mm f/2.8 lens,
ISO 800,
1/60sec at f/4

Other suppliers such as florists, cake designers and hotel venues will gratefully receive your images to use in publicity. By allowing them to use your images you will start to build strong relationships within the wedding industry. These businesses will often promote you to their clients in turn. Referrals are about the best form of advertising – after all, they cost you nothing.

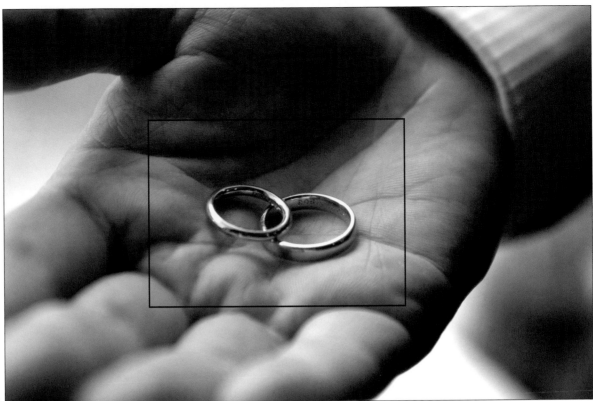

*Nikon D2x,*
*28-70mm f/2.8 lens,*
*ISO 200,*
*1/60sec at f/3.2*

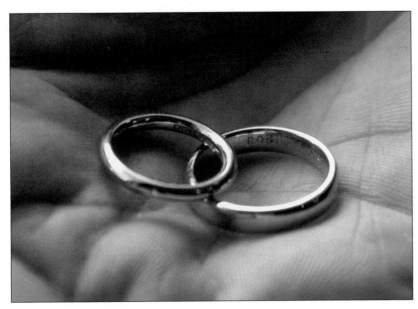

A macro or close focusing lens is helpful when getting in close to photograph detail shots. If you do not have a macro lens, then cropping your image will give you a similar look. Remember that as you crop you will reduce the quality of the image, as you are now relying on far fewer pixels. This is best suited to images that are designed to be used small on an album page. When taking detail shots with cropping in mind, try to shoot on the lowest ISO setting that you can, as you will have much less noise (or digital grain) to deal with. Move your subject towards a window or other light source if need be.

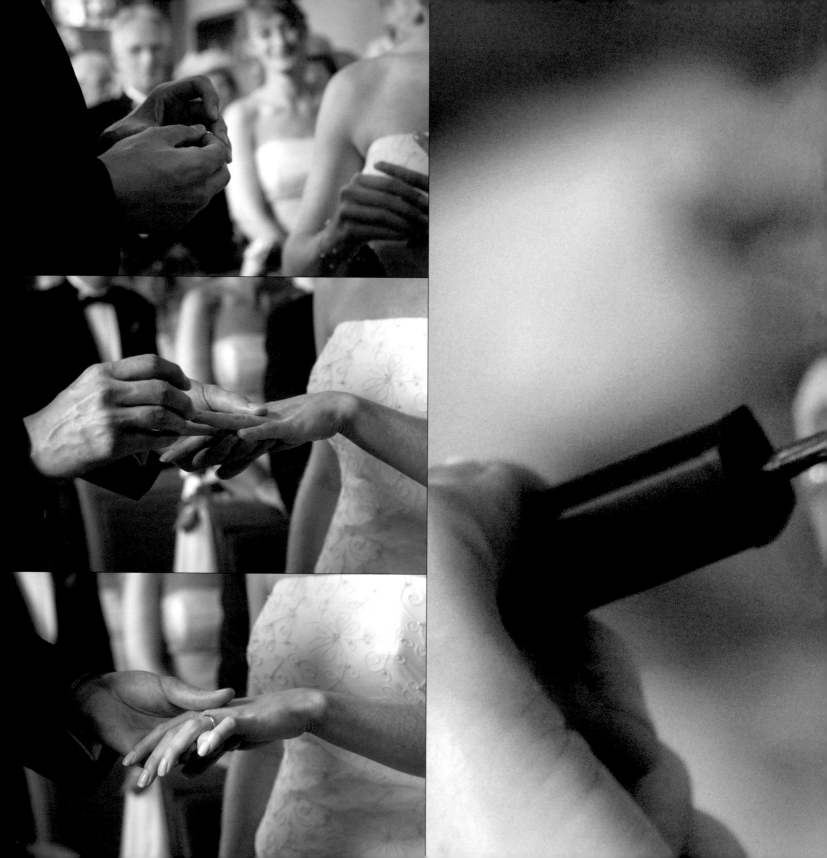

## The Wedding Breakfast

When photographing table decorations, try using a very wide aperture to shrink the depth of field. This will help to pick out the detail you are concentrating on.

**Just before the guests are called into the wedding breakfast is the ideal time to capture the room in all its glory. Candles will be lit, wine bottles will be in place and the whole setting will be perfect. It is a good idea to take some shots earlier as the light may fail with an evening or autumn reception, then pop back in just before the guests are called in when the finishing touches have been put in place.**

*A dynamic album design will have plenty of room for detail shots, which show the care and planning that has been put in prior to the wedding. A great amount of time may have been spent selecting just the right flower, favour, glass or place setting. Photographing these in pristine condition preserves the memory forever.*

*The food is an important aspect of the wedding that is often overlooked. Again, hour upon hour of planning will have gone into the menus and a photographic record can be a wonderful reminder of a very special meal. The wedding breakfast has a pivotal role to play. It is where stories are swapped and old acquaintances brought together. The sharing of food is a gesture of generosity and friendship and the wedding breakfast a symbol of what will follow in the years to come – meals eaten with family and friendships going forward. Photographing this aspect of the wedding brings another dimension to the record that you are creating.*

*Many wedding cakes now are small works of art, fantastically made with sophisticated contemporary designs. Recording the detail before it is cut preserves the cake long beyond the moment. With a little imagination you can create some really eye-catching images here. Try coming in close and photographing the detail, or raising the level of the camera by standing on a chair and looking down on the cake. Just by changing the angle of the frame, you can challenge the conventional shot and produce something that will stand out in the album.*

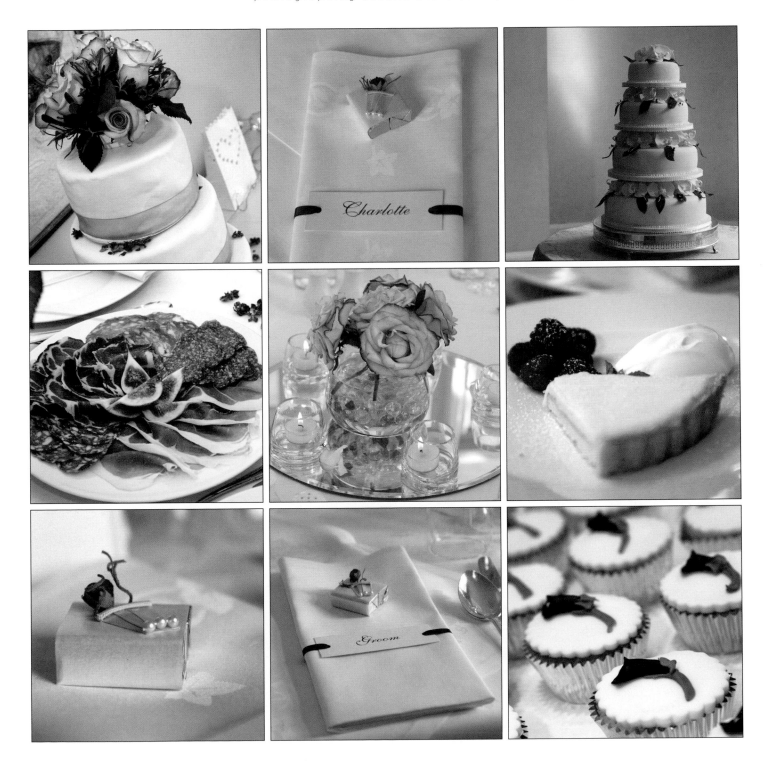

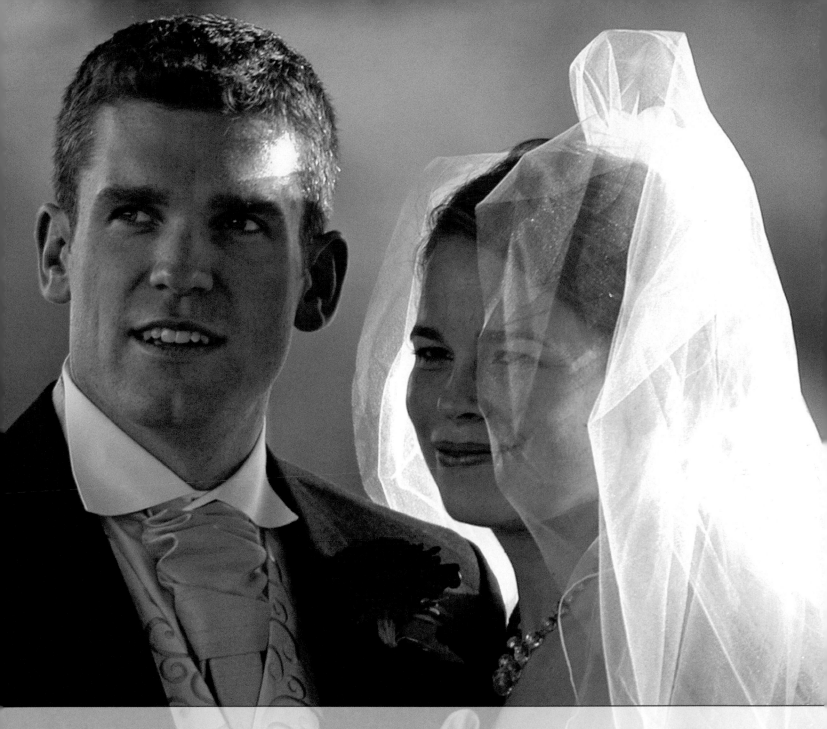

**Chapter 4** *Step-by-Step Documentary-Style Wedding*

*The soft natural light in the shot in the hotel room comes from windows to the right hand side. For the shots of the groom and his parents, some fill-in flash was added as we were in a narrow dimly lit courtyard with all the light coming from directly above. This lighting situation causes deep, unflattering shadows in the eye sockets and under the nose and chin. A little fill flash, set a stop and a half below the ambient light reading opens up the shadow area whilst retaining a natural look.*

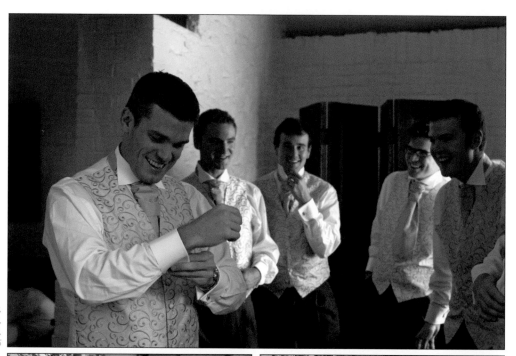

*Nikon D2x,
28-70mm f/2.8 lens,
ISO 800,
1/80sec at f/4.5*

*Nikon D2x,
28-70mm f/2.8 lens,
ISO 800,
1/60sec at f/4.5,
Nikon SB80DX speedlight with an
adjustment of −1.5 stops*

**11.45** Arrive at the hotel to photograph the boys getting ready. This is a great time to take natural shots that explore the friendship between the individuals.

**11.55** After photographing the groom, ushers and best man in their preparations, there is time for some quick portraits of the groom with his parents outdoors. Again, I choose to take gentle images where the subjects share some intimacy, aiming to hint at the relationship between the three of them.

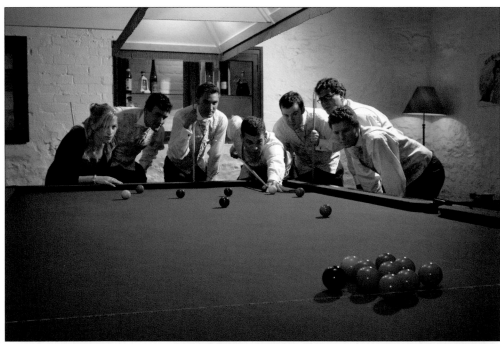

*Fuji S2Pro,
28-70mm f/2.8 lens,
ISO 800,
1/60sec at f/6.7*

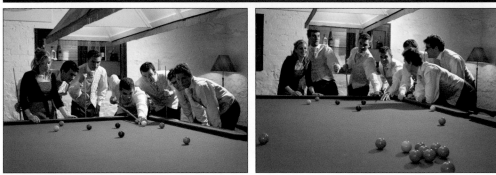

**12.05** I ask my assistant to take control of the camera in the billiards room, leaving me free to light the shot and direct the action. There is a little on-camera flash, but the strongest light source comes from a Bowens flash head, placed high up at the rear of the room on the right. The flash is balanced carefully to retain a warm tungsten glow from the lights above the table and in the background. Using only on-camera flash would have rendered the scene flat and lacking in atmosphere.

*This portrait of the groom's parents was captured just after the images taken outdoors on the previous page. The artwork in the hotel lobby gives a nice feeling of space, while the natural light from the windows is soft and flattering. Again, a little fill flash was used to bring detail to the shadow areas.*

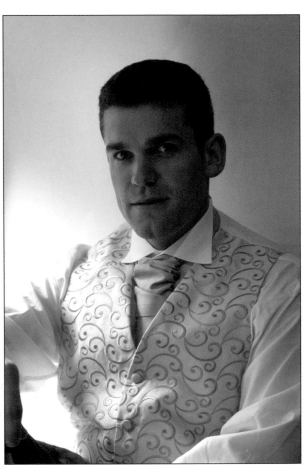

*Nikon D2x, 28-70mm f/2.8 lens, ISO 800, 1/60sec at f/4.5, Nikon SB80DX speedlight with an adjustment of −1.0 stop.*

*Nikon D2x, 28-70mm f/2.8 lens, ISO 800, 1/30sec at f/4.5*

**12.11** Having a second photographer present means that while she packs away the lights in the billiards room, I can capture some quiet portraits of the groom. It is great to take this opportunity with him early on in the day as the focus later will undoubtedly be on the bride. For this shot, I work at a slow shutter speed to avoid using flash. I take multiple frames so I can edit out any that may have camera shake.

**12.16** Leave to meet the bride.

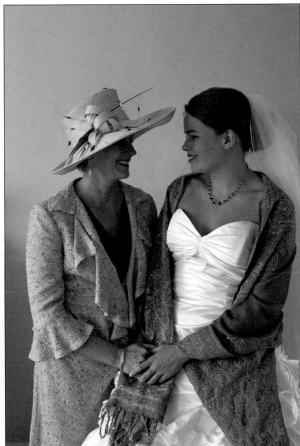

*Nikon D2x, 28-70mm f/2.8 lens, ISO 640, 1/50sec at f/3.5*

*Nikon D2x, 28-70mm f/2.8 lens, ISO 640, 1/60sec at f/3.5*

**12.50** Arrive at the bride's parents' house to capture gentle shots before the wedding.

**12.56** Photograph the bride with her mother. I also take a more formal shot, where they are both looking straight towards the camera, but this one has particular warmth in the connection between mother and daughter.

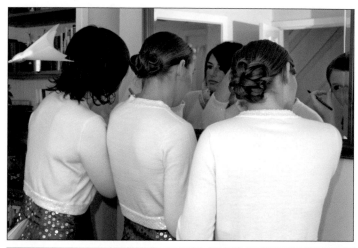

*Nikon D2x,*
*Nikon AFS 28-70mm f/2.8 lens,*
*ISO 640,*
*1/50sec at f/3.5*

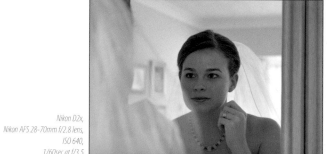

*Nikon D2x,*
*Nikon AFS 28-70mm f/2.8 lens,*
*ISO 640,*
*1/60sec at f/3.5*

*Nikon D2x,*
*28-70mm f/2.8 lens,*
*ISO 640,*
*1/50sec at f/3.5*

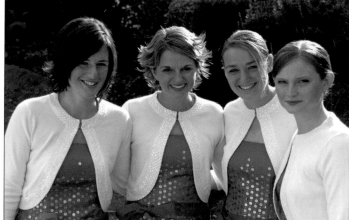

*Nikon D2x,*
*Nikon 28-70mm f/2.8 lens,*
*ISO 250,*
*1/800sec at f/5*

**13.03** The bride is ready; photograph her checking her make-up.

**13.07** I take the opportunity to photograph the bridesmaids together in the garden.

*Fuji S2Pro,*
*Nikon AFS 28-70mm f/2.8 lens,*
*ISO 400,*
*1/250sec at f/4*

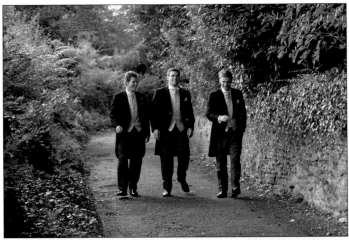

*Fuji S2Pro,*
*Nikon AFS 28-70mm f/2.8 lens,*
*ISO 400,*
*1/250sec at f/2.8*

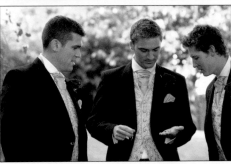

*Fuji S2Pro,*
*Nikon AFS 28-70mm f/2.8 lens,*
*ISO 400,*
*1/250sec at f2.8*

*Nikon D2x,*
*Nikon AFS 28-70mm f/2.8 lens,*
*ISO 400,*
*1/320sec at f/4*

**13.30** Arrive at the church. Finding the groom with his best man and an usher, I am eager to get a shot of the wedding rings before the ceremony. The shot above of the men 'arriving' lends a narrative to this page of the album. As they had actually arrived before me, I have to ask them to restage the event.

**Before** the wedding, introduce yourself to the person that is to lead the service. By seeking their permission for photography, you will reassure them that you are not going to be intrusive and you can establish where you are allowed to shoot from during the ceremony. I like to be up at the front for a church wedding, especially if there are choir stalls. This is an ideal position as you are out of the way but, with a long lens, you can catch the small exchanges between the bride and groom. At this wedding, the vicar did not wish to have a photographer near the front so I had to make do with the odd shot from the back of the building. It is usual for no flash to be used during the ceremony, only during shots of the signing of the marriage register.

*Nikon D2x,*
*Nikon AFS 28-70mm f/2.8 lens,*
*ISO 250,*
*1/1000sec at f/6*

*Far left:*
*Nikon D2x,*
*Nikon AFS 28-70mm f/2.8 lens,*
*ISO 800,*
*1/30sec at f/3.5*

*Fuji S2 Pro,*
*Nikon AFS 28-70mm f/2.8 lens,*
*ISO 800,*
*1/750sec at f/2.8*

*Nikon D2x,*
*Nikon AFS 28-70mm f/2.8 lens,*
*ISO 800,*
*1/50sec at f/3.5*

*Fuji S2 Pro,*
*Nikon AFS 28-70mm f/2.8 lens,*
*ISO 400,*
*1/180sec at f/5.6*

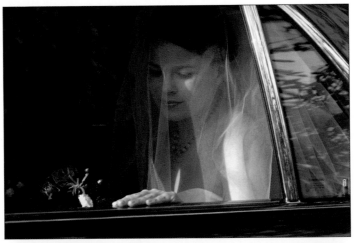

*Nikon D2x,*
*Nikon AFS 28-70mm f/2.8 lens,*
*ISO 400,*
*1/160sec at f/5.6*

*Nikon D2x,*
*Nikon AFS 28-70mm f/2.8 lens,*
*ISO 400,*
*1/160sec at f/5.6*

*Nikon D2x,*
*Nikon AFS 28-70mm f/2.8 lens,*
*ISO 400,*
*1/160sec at f/5.6*

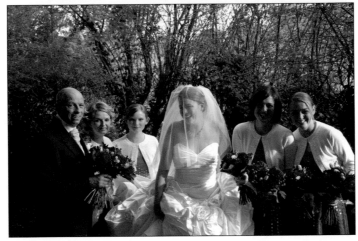

**13.50** The last guests are seated in the church.

**13.58** The bride arrives leaving little time for photography. In this situation, it is important to work quickly with the minimum of fuss so that you do not hold up proceedings or add to the bride's nerves.

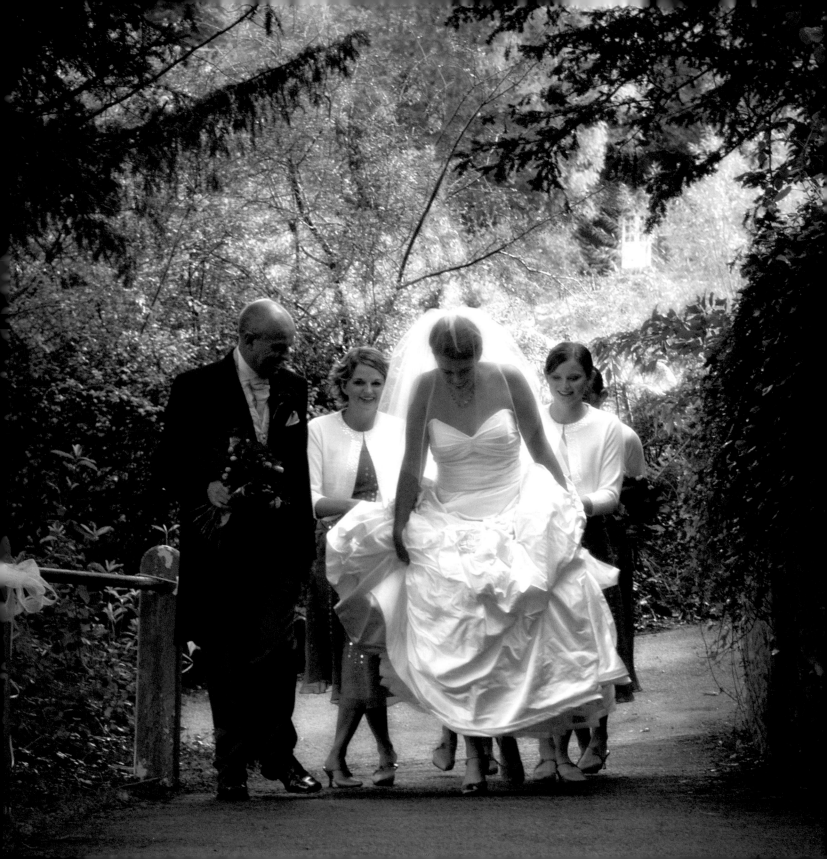

*Facing page:*
*Nikon D2x,*
*Nikon AFS 28-70mm f/2.8 lens,*
*ISO 400,*
*1/160sec at f/5.6*

*Nikon D2x, Nikon AFS 28-70mm f/2.8 lens, ISO 400, 1/160sec at f/5.6*

*Running ahead, I was able to turn quickly and catch a natural shot of the bride, flanked by her father and bridesmaids, as they rushed up the hill towards the church. The mood was happy and expectant and the trees and foliage framed the group perfectly. It is important to be fully alert to what is happening in order to catch moments like the brief exchange above between the bride and her father. Shots of this kind cannot be set up or staged yet work together beautifully as a sequence in the final album.*

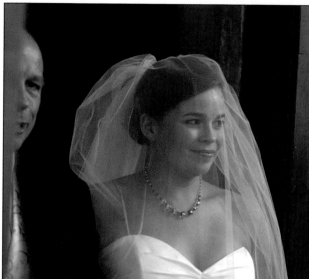

*Nikon D2x,*
*Nikon AFS 28-70mm f/2.8 lens,*
*ISO 800,*
*1/60sec at f/3.2*

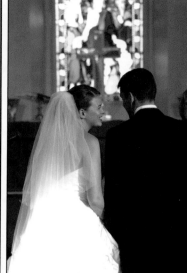

*Nikon D2x,*
*Nikon AF-S VR 70-200mm f/2.8 lens,*
*ISO 800,*
*1/60sec at f/4*

*Nikon D2x,*
*Nikon AF-S VR 70-200mm f/2.8 lens,*
*ISO 800,*
*1/60sec at f/4*

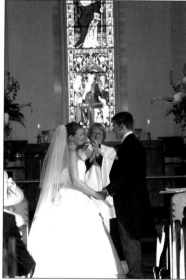

*Nikon D2x,*
*Nikon AFS 28-70mm f/2.8 lens,*
*ISO 800,*
*1/60sec at f/3.2*

*As the vicar requested that I remain at the back of the church, I could only take a limited number of photographs during the ceremony. However, I had already taken pictures of the groom and best man at the front of the church before the ceremony and when these were placed on the same page of the album the lack of 'upfront' shots was not apparent.*

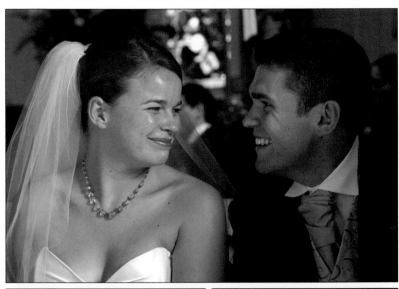

*Nikon D2x,*
*Nikon AFS 28-70mm f/2.8 lens,*
*ISO 800,*
*1/80sec at f/4*

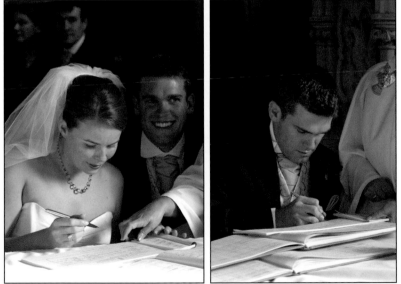

**14.06** The bride enters the church and the ceremony begins.

**14.45** As there is good natural light in the church, I can photograph the signing of the register without the use of flash.

*Fuji S2 Pro,
AFS 28–70mm f/2.8 lens,
ISO 800,
1/60sec at f/4*

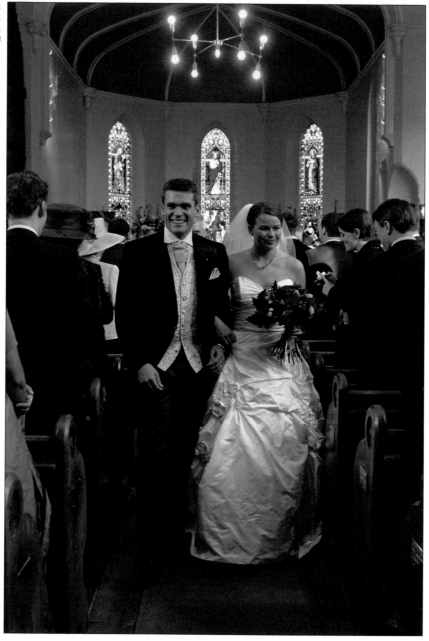

*This shot was taken by my assistant as the newly-married couple walk down the aisle. It captures the moment beautifully and is full of the happiness of the event.*

*Nikon D2x, AFS 28–70mm f/2.8 lens, ISO 400, 1/320sec at f/4*

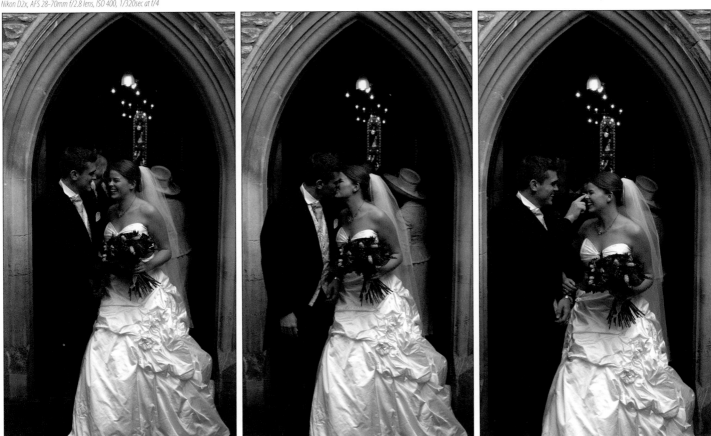

**14.56** Ceremony over, the bride and groom leave the church. By asking the ushers to hold the other guests back just for a moment, it is easy to capture the couple at the door of the church, which provides a perfect frame for them. Encouraging your subjects to interact brings energy to these shots.

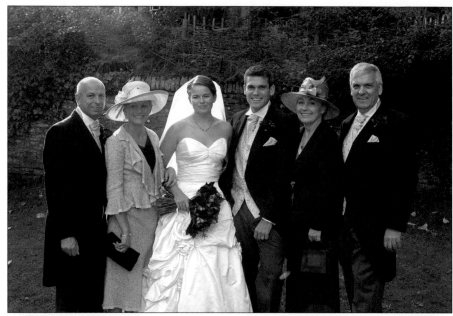

*Nikon D2x,*
*AFS 28-70mm f/2.8 lens,*
*ISO 400,*
*1/250sec at f/5.6*

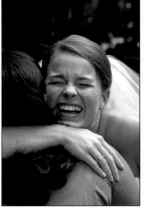

*Nikon D2x,*
*AFS 28-70mm f/2.8 lens,*
*ISO 400,*
*1/60sec at f/4*

*Nikon D2x,*
*AFS 28-70mm f/2.8 lens,*
*ISO 400,*
*1/250sec at f/4.5*

**15.00** Once I have grabbed some shots at the doorway, I choose to photograph in a low-key manner, mingling with the guests. This allows things to be more natural and encourages family and friends to rush up to greet the bride and groom. Shots taken at these moments can be full of emotion and spontaneity that is not readily present in set up photographs.

**15.10** I scout out an area for family groups where my subjects are back lit (this ensures that they are not squinting into the sun and separates them from the background) and meter the scene. Although I mostly work with my camera in aperture priority mode (so I can quickly choose the depth of field in my images but expose and work with speed), I now switch my camera to manual. Once my camera is set, the exposure should only need adjusting if the weather conditions change, or if I move location during the group shots.

*Nikon D2x,
AFS 28-70mm f/2.8 lens,
ISO 400,
1/250sec at f/5.6*

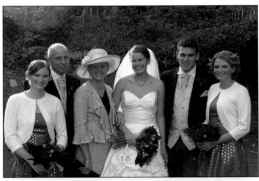

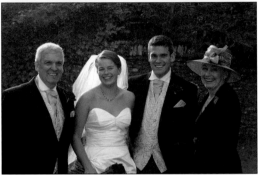

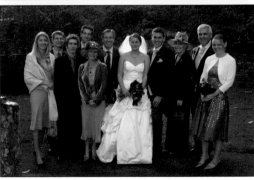

**15.15** With the help of my assistant and an usher, I invite both the bride and groom's family to gather to one side of my selected area. Working from a list, I can then quickly bring the people I need into the shot. It is important to work speedily in an organised fashion, but also to keep a sense of fun to the proceedings, otherwise the expressions and poses may look rather tired and static.

**15.27** Group shots finished. At this wedding, a total of nine different family groupings were taken. Each shot was built up logically in this order: bride and groom with bride's parents, then adding her siblings, then their partners or other very close family members such as grandparents, and finally adding the outer family. I then ask the bride, groom and the bride's parents to remain and invite the groom's parents to join them. After this shot I build up the groom's family following the same pattern (see pages 46-47).

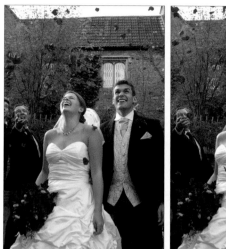
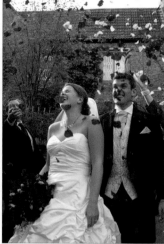

*Nikon D2x,
Nikon AFS 28-70mm f/2.8 lens,
ISO 400,
1/50sec at f/8*

*Nikon D2x,
Nikon AFS 28-70 f/2.8 lens,
ISO 500,
1/50sec at f/8*

**15.29** The confetti-throwing works well as a sequence, capturing the couple's natural reactions.

**15.37** Photograph the complete wedding party. I often do this shot at the reception venue, but as this wedding is going to a city location without gardens, I take this on the lane leading up to the church.

**15.45** The guests pile on to vintage buses and are transported to the reception.

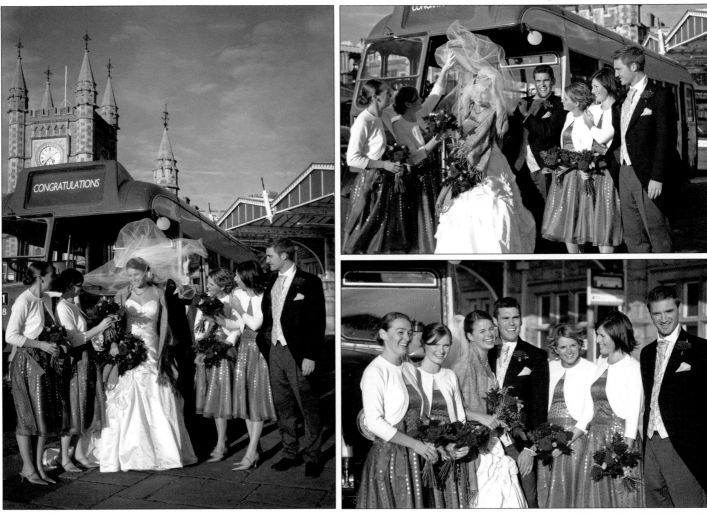

*Nikon D2x, Nikon AFS 28-70mm f/2.8 lens, ISO 400, 1/600sec at f/8*

*Fuji S2 Pro, AFS 28-70mm f/2.8 lens, ISO 400, 1/2000sec at f/2.8*

**16.19** The reception venue is next to a busy railway station. Deciding to break with tradition and provide my clients with something out of the ordinary, I choose to use the station as a set for portraits of the bride and groom, as well as pictures of the bridal party.

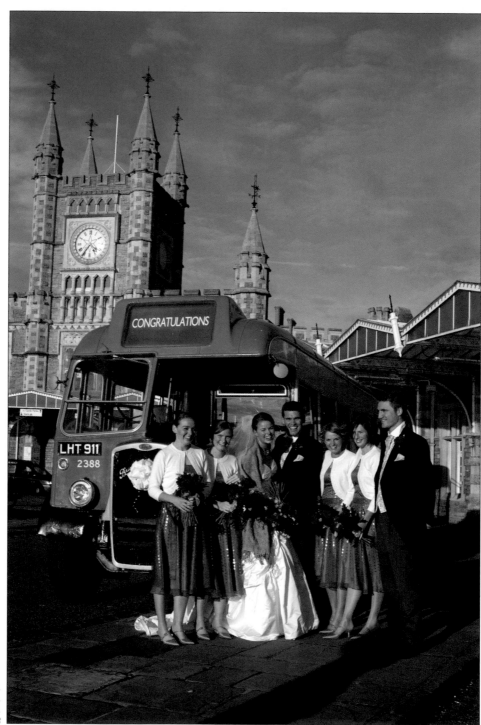

*Nikon D2x,*
*Nikon AFS 28–70mm f/2.8 lens,*
*ISO 400,*
*1/1600sec at f/8*

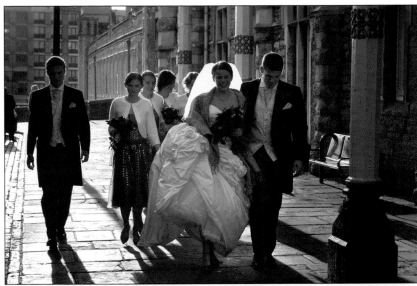

*Nikon D2x,*
*Nikon 28 AFS 28-70mm f/2.8 lens,*
*ISO 400,*
*1/400sec at f/8*

*Nikon D2x,*
*Nikon AFS 28-70mm f/2.8 lens,*
*ISO 400,*
*1/250sec at f/8*

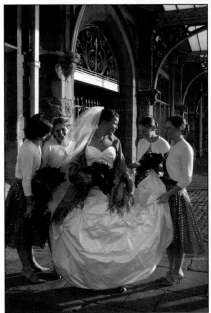

*Nikon D2x,*
*Nikon AFS 28-70mm f/2.8 lens,*
*ISO 400,*
*1/320sec at f/8*

*As we walked towards the station, I looked back and saw the beautiful warm light and long shadows cast by a low autumn sun. I decided it would make a great image if I could capture this light with my bride and groom. I asked the wedding party to wait a moment and told the bride and groom to walk a few paces in front while my assistant and I raced ahead. As they started to walk, I took natural looking shots that fully exploit the lovely light.*

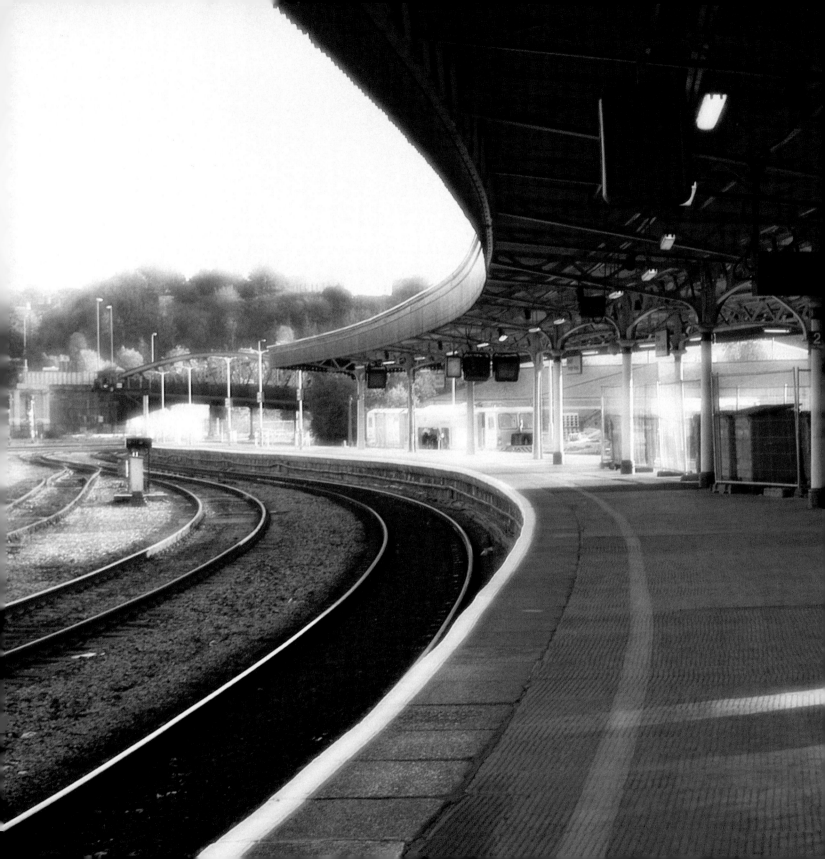

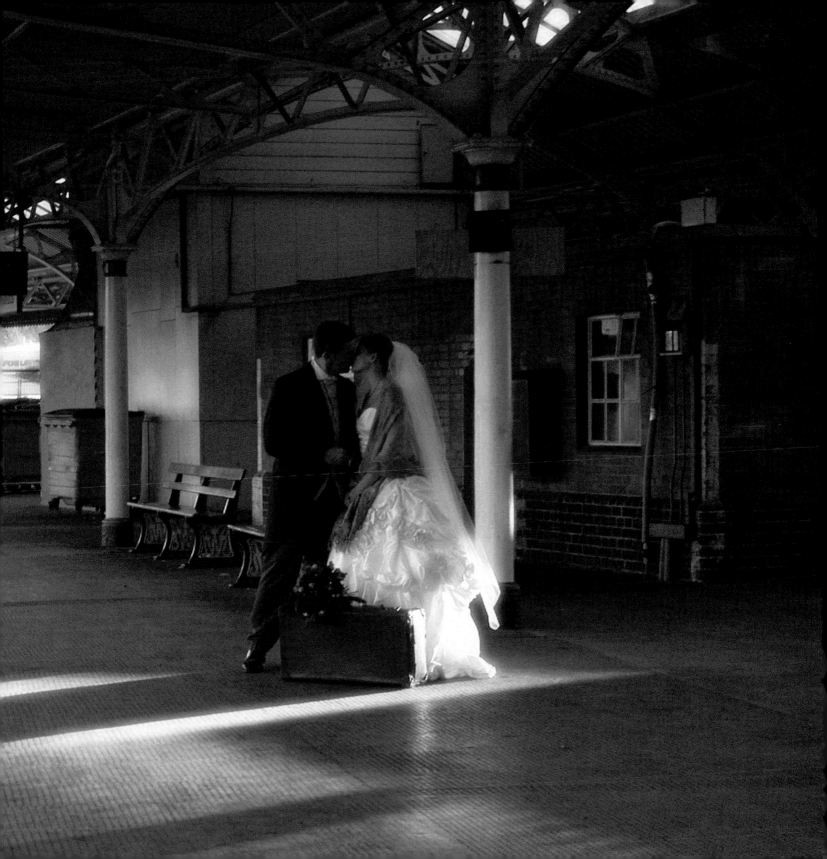

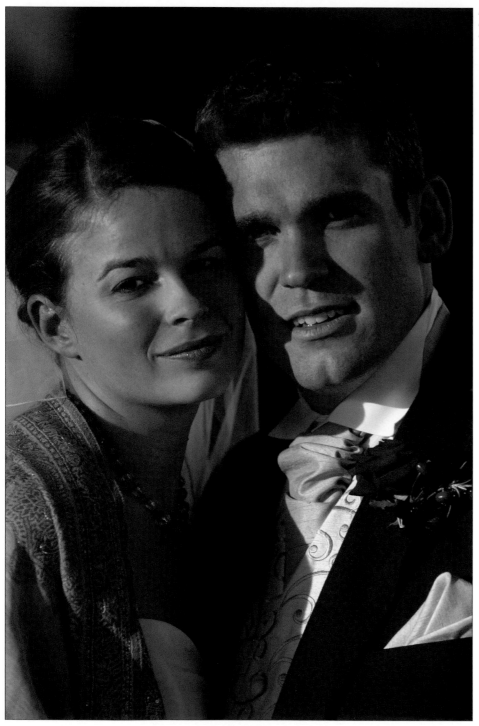

*Nikon D2x,*
*Nikon AF-S VR 70–200mm f/2.8 lens,*
*ISO 200,*
*1/400sec at f/3.5*

*Taking inspiration from 'film noir', I made the most of the beautiful low-angled light to increase the cinematic look. Being different and trying something new at each shoot will make your images stand out from the crowd.*

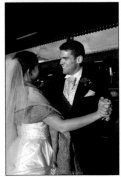

*Nikon D2x,
Nikon AF-S VR 70-200mm f/2.8 lens,
ISO 200,
1/500sec at f/3.5*

*Nikon D2x,*
*Nikon AFS 28–70mm f/2.8 lens,*
*ISO 640,*
*1/45sec at f/5*

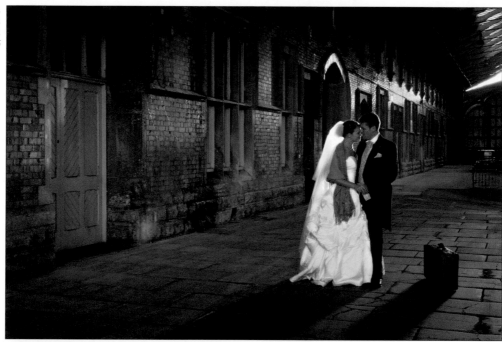

*Fuji S2 Pro,*
*Nikon AFS 80–200mm f/2.8 lens,*
*ISO 200,*
*1/500sec at f/3.3*

*Nikon D2x,*
*Nikon AF-S VR 70–200mm f/2.8 lens,*
*ISO 200,*
*1/400sec at f/3.5*

*Keeping alert to your surroundings allows you to take full advantage of the unexpected. As we returned to the reception, walking through an old passenger shed, an extraordinary shaft of light cut through the building from a slit in the roof at the far end. I quickly shot the image, above, as the last of the evening sunshine was about to sink below the horizon.*

*Fuji S2 Pro,*
*Nikon AFS 28-70mm f/2.8 lens,*
*ISO 800,*
*1/60sec at f/2.8*

*Nikon D2x,*
*Nikon AF  S 28-70mm f/2.8 lens,*
*ISO 800,*
*1/60sec at f/5*

*Nikon D2x,*
*Nikon AFS 28-70mm f/2.8 lens,*
*ISO 800,*
*1/60sec at f/5*

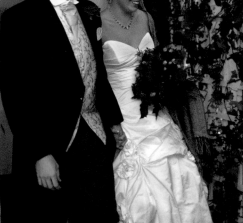

*Fuji S2 Pro,*
*Nikon AFS 28-70mm f/2.8 lens,*
*ISO 800,*
*1/60sec at f/2.8*

**17.08** The bride and groom make their entrance to the reception venue and have a well-deserved glass of champagne.

**17.31** The cake is cut.

**17.40** The guests are called to join a line-up to meet the bride and groom before going in to dinner.

**18.16** The bride and groom sit down with their guests. While the dinner is being served I take a break before setting up flash heads to light the first dance.

*Nikon D2x,*
*Nikon AF-S VR 70-200mm f/2.8 lens,*
*ISO 800,*
*1/60sec at f/4*

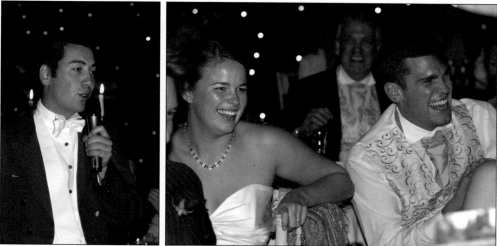

*Nikon D2x,*
*Nikon AF-S VR 70-200mm f/2.8 lens,*
*ISO 800,*
*1/60sec at f/4*

*Nikon D2x,*
*Nikon AF-S VR 70-200mm f/2.8 lens,*
*ISO 800,*
*1/60sec at f/4*

*Nikon D2x,*
*Nikon AF-S VR 70-200mm f/2.8 lens,*
*ISO 800,*
*1/60sec at f/4*

**20.25** The speeches are announced. The usual order is father of the bride, groom and then the best man.

**20.44** The groom speaks (the bride also speaks briefly).

**20.59** The best man's speech prompts hysterical laughter from the bride, groom and guests.

*Nikon D2x,*
*Nikon AF-S VR 70-200mm f/2.8 lens,*
*ISO 800,*
*1/60sec at f4*

*Nikon D2x,*
*Nikon AF-S VR 70-200mm f/2.8 lens,*
*ISO 800,*
*1/60sec at f/4*

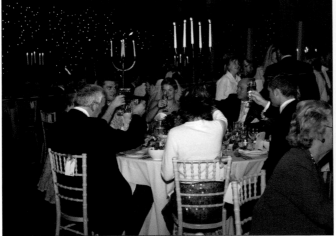

*Fuji S2 Pro,*
*28 AFS 28-70mm f/2.8 lens,*
*ISO 800,*
*1/60sec at f/4.8*

*Nikon D2x,*
*Nikon AF-S VR 70-200mm f/2.8 lens,*
*ISO 800,*
*1/60sec at f/4*

**21.27** The band starts.

**21.33** The first dance begins; the bride and groom dance as if expertly choreographed.

**21.37** The room explodes into loud applause. The band plays on and the guests begin to fill the dance floor.

**21.50** My final fame is taken. I head back to my office, exhausted but happy, to download and back up all the images taken.

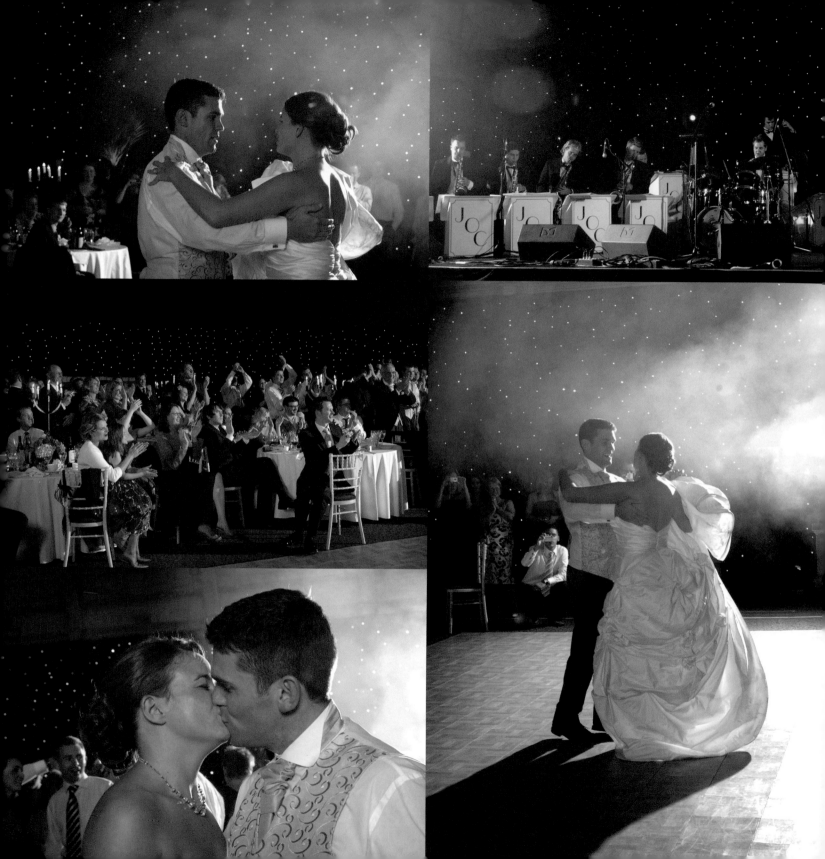

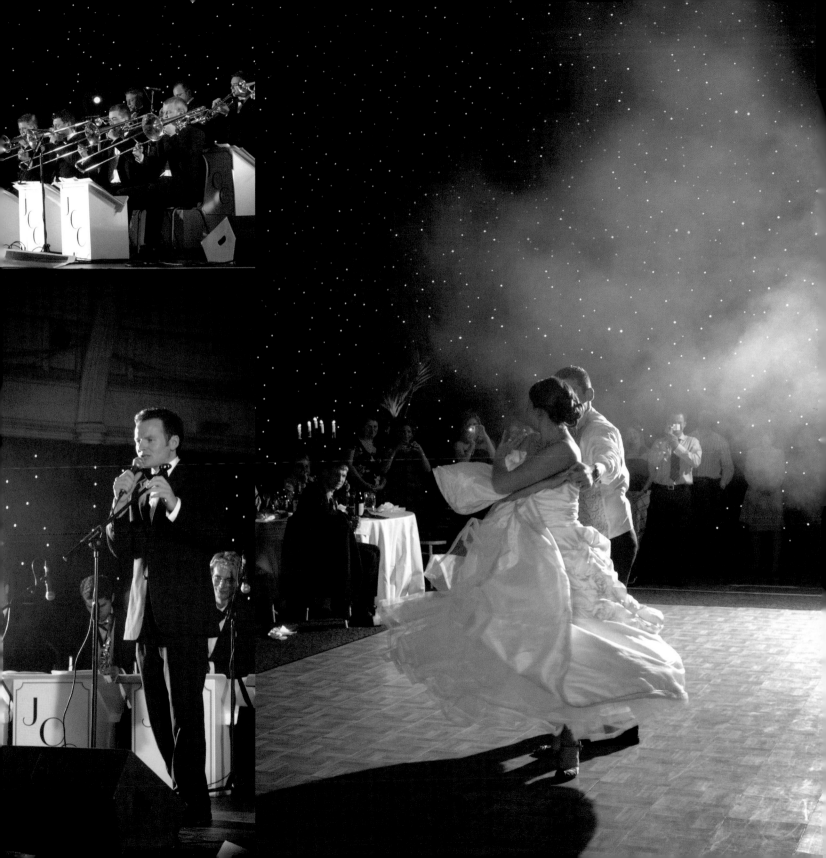

**Chapter 5** *The Business of Professional Photography*

## Your Professional Image

Always make sure you have your
best recent work on show.

**To grow a healthy business you need to get it noticed. Creating the right image for your business is important as this is the first thing prospective customers will see. Once you settle on a look, logo or design, use it across all of your publicity material from business cards to magazine adverts and your website; this way you will be building your 'brand' or business identity.**

The benefits of creating a strong identity will pay off when your business becomes known. Consistency in your advertising material will ensure that customers remember you. By keeping your designs clean and always using up-to-date images, you will show your style of photography to its best advantage.

### Designing a Website

The web is an exciting and powerful marketing tool. It is a space where you can showcase your work and create galleries of images to impress your customers. But even the most sophisticated website is useless unless it can be found easily. I promote my website on all of my advertising material. I do this as I hope that prospective clients will look at the images on the web and get a feel for my style and an understanding of what I offer before they contact me. It is important that any site, even the most simple, is kept up-to-date with recent images that have plenty of impact and text that is relevant and insightful.

When building your site (whether you do this alone or employ a professional web designer), it is important that it is easy to navigate around. As sites become increasingly more sophisticated, viewers are asked to work harder to find what they are looking for.

By trying to visualise your target clients, you will be able to angle your advertising towards that group more effectively. I chose to stay away from soft whites, silver and gold, deciding instead to use black as a contemporary backdrop to my advertising material.

I use the same design on my home page as I do in other advertising material. This helps to reinforce my 'brand'. The title font is put into the web page as an image (a 'gif' file) so that it will display the same on all web browsers. Keeping the design on your 'home' or 'index' nice and clean with clear and accessible navigation buttons will make it easy for your customers to find what they are looking for quickly.

*The time people spend on many websites is as little as 10 seconds so it is important that the pages are clear, the images arresting and information readily found. Make sure that you have a menu bar that is easily accessible as this will allow viewers to navigate through the pages and quickly get a feel for your work. As a photographer, it is the images on your site that will be key to generating new business – always ensure that you have your best work on show.*

A website is a great place to showcase your work. Building galleries into your site will allow customers to really get an idea of your capabilities. Each of the thumbnail images on my site works as a link; when clicked the image will be displayed larger on its own page. Notice that the navigation buttons are in exactly the same place as on the home page.

When one of the images on the gallery page is clicked, a new page opens up with a larger, easy-to-view version of the image. New navigation buttons allow you to scroll forwards and backwards through the images or to go back to the gallery page. Your site should be logical to navigate through and there should always be an easy way to exit the page you are viewing.

The great advantage of a website is that you are in control of the content. On my site I have complete wedding albums for my clients to browse through. This way I am not only able to show the quality and consistency of my work, but also make a feature of the way I design my clients' albums.

## Getting Seen

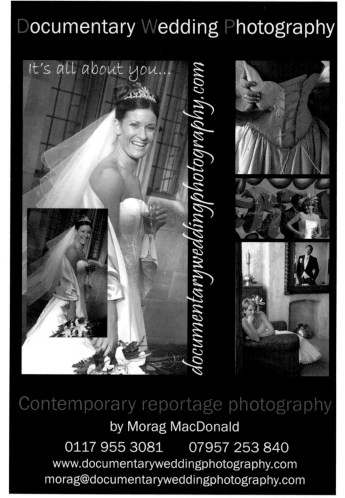

**Documentary Wedding Photography**

It's all about you...

*documentarweddingphotography.com*

Contemporary reportage photography

by Morag MacDonald

0117 955 3081      07957 253 840

www.documentaryweddingphotography.com

morag@documentaryweddingphotography.com

An example of a magazine advert where I have used multiple images but still kept the main image that is used on my brochures and website. Notice that my website address is prominently visible on all advertising material.

*Marketing and promotion can come in many guises. Once your business has been up and running for a few years, you will find that much of your work comes from referrals and reputation. At the start it is a different story – you must find different ways to promote your business.*

*Business cards are a great, cost effective way to get your name about. You can always have some in your wallet and more in your camera bag. They are light, portable and easy to hand out. When I started up, I decided to get postcards made up instead of business cards. Although they do not fit into people's wallets, their larger size has been a great way of showing images to prospective clients. I didn't plan this as a shrewd business move, however; it was simply that my printers were having a sale and producing full colour, double-sided, matt laminated cards at a bargain price! With this acknowledgement, I must admit that the cards have worked for me. I give them out at wedding fairs, slip them into all of my correspondence and put them into print wallets when I send out reprints. Clients have told me that they often pass them on to their friends, so spreading the word about my business.*

*Advertisements in the local press and bridal magazines can work very well, however this sort of exposure can be expensive. When you are first starting out in business, it is worth asking if you can get a discount off their advertised rates. You will find that some magazines will be keen to support you at the start, in the hope that you build a good relationship with them and keep advertising in the years to come. The price that advertisers quote is only the actual price if you accept it. It is well worth negotiating on the rate.*

*Keep a record of who you advertise with and ask your clients on first contact how they heard about you. This will help you to evaluate which is most cost effective.*

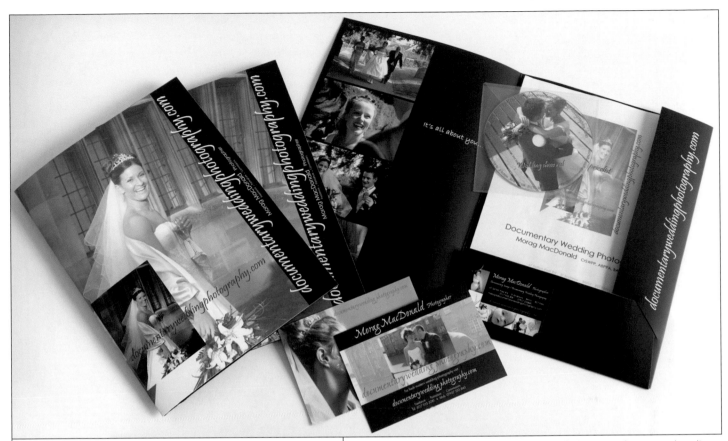

Make sure you include your website address in any marketing materials. This way your clients will have the opportunity to view many more images.

Instead of brochures, I have had folders printed up to send to clients. This way I can change the contents as often as I please without incurring the cost of complete re-printing. When I receive an enquiry, I send it out containing a pricelist, a CD show reel of my best work, a postcard and a personal covering letter.

### Website links and Wedding Fairs

*Linking your website to wedding planning sites is a great way to generate traffic to your website. As online shopping continues to grow, it is increasingly the web that brides turn to when researching services for their wedding. Wedding planning sites will promote your business in return for a subscription fee. You are usually asked to choose certain geographical areas to advertise in, so any bride looking for a photographer in your area will be given a link to your site. I have found this an excellent way of generating business.*

*Wedding fairs are another great way to reach potential customers. Once you have paid for your pitch, you must decide how you are going to attract the public to your stand. Large, framed images will grab people's attention as they pass by. A sign or banner will help to reinforce your brand. Your stand should have your albums set up so that customers may easily browse through them. Information needs to be displayed so that it can be picked up easily. It may be hard for everyone to get close and look through your albums, so have a pile of cards or brochures to give people to take away.*

## Digital Workflow

A sound digital workflow will ensure that everything is stored and delivered to your client in perfect condition. Digital files need to be securely backed up as soon as you are able, in order to protect yourself against accidental loss. Many photographers bring laptops or other storage devices to weddings so that they may back up work and re-use memory cards as they go. I prefer to carry more memory cards with me and back up in one go after the event. This way I am always alert to what is happening at the wedding and ready to shoot as things present themselves.

*Nikon D2x, 28-70mm lens, ISO 400, 1/500sec at f/4*

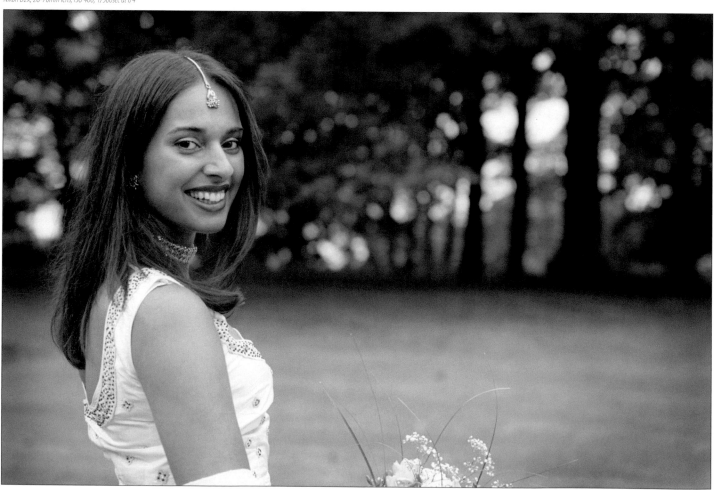

As soon as I return from a wedding, I set up a folder on my computer's hard drive. I name this folder with the day's date followed by the full names of the bride and groom. Inside this folder, I set up a sub folder and name it 'Originals'. I now download my cards in sequence (remember that I number my cards and shoot in sequence, see Chapter 2, Planning and Equipment). I always stick to the sequence when downloading so that I know that I have not lost a card. Once the images are in the Originals folder I back it up to DVD.

I now make a copy of Originals within the client folder and name it 'Edited originals'. First I edit out any blinks, grimaces and poor exposures or compositions. Where I have a number of frames shot in one situation, I choose the best and edit out the others. This ensures that I do not waste time working on files that later will not be used.

When I have edited my images down, I make a third folder within my client's folder and name it 'TIFFs'. I now run a Photoshop 'action' turning all remaining files into TIFFs as this file format is not 'lossy' and I may save the images with multiple layers.

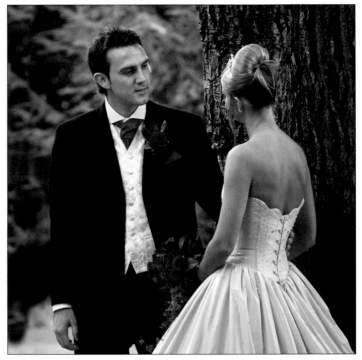

Nikon D2x, Nikon AF-S VR 70-200mm f2.8 lens, ISO 200, 80 sec, f4.5

Next I assess each file for colour, density and composition. I identify which image will work best in black and white or sepia and run actions to convert the images in Photoshop. I always save the black and white or sepia image as a second layer so that I may return to the original if need be (for more on digital processing see Chapter 6, The Digital Darkroom). Once the images are processed, I rename the files using a program called FotoStation. I now have my finished TIFFS in order, with the groom's name and a consecutive number: White 001, White 002 etc.

The final stage is to make two further folders in my client folder, one named 'Hi-res JPEGs' and the other 'Low-res JPEGs'. Running further actions in Photoshop, I am able to save copies of the finished TIFFs in the smaller, compressed JPEG file format to use for proofing and web sales.

It is vital to archive your work at this point to guard against computer failure or other accidental loss. I copy the whole client folder to an external hard drive for easy access. I also put the folders onto DVD's in case the drive fails. It is essential that your files are securely backed up as you cannot re-shoot a wedding.

*It is vital that your files are securely backed-up as you cannot re-shoot a wedding.*

## Proofing and Web Sales

There are many companies that will host and sell your images online.

**Once all the images are prepared, they need to be delivered to the client. There are many ways of proofing; some photographers, for example, wait until the couple come back from honeymoon and invite them over for an AV presentation. This way the photographer gets to share the couple's pleasure and emotion as they first see their images and are transported back to their day. Others arrange and** **present photographs in a preview album or image box, upload the images to a website or arrange them as a CD or DVD slideshow.**

Online proofing has become a popular way to present images to clients and I offer it alongside an inkjet printed preview booklet together with a CD slideshow. For the latter, I print out contact sheets

Online proofing is a popular way to present images for clients to choose from. Once images are uploaded to the web they are organised into client 'folios'. Each one is ordered by the date of the wedding and titled with the couple's first names. There is the option to set a password for each folio or leave them non-password protected. When a link is clicked, individual folios open up.

20 to a page using Epson PhotoQuicker software. These pages are bound with a personally designed cover to make up an A4 booklet. In the back of the booklet there is a pocket holding a CD, which contains a slideshow of all of the images set to music. The CD is produced using a program called PicturesToExe.

There are many companies that will host and sell your images online. I use a company called The Image File. For a monthly fee I am able to simply upload my low-resolution JPEG images to their web space, set out what products and print sizes I offer and include a price plan. When clients want to view their images, they go to my website and click on a link to 'Online weddings'. This opens up a folio page where all my online weddings sit, in date order, with an image from their wedding and the names of the couple. Although the images are stored on The Image Files' web space, it appears seamless as the pages are designed to look like my site. From here clients may browse through and order images securely online. When an order has been made, I receive an email with all the details. I then fulfil the order and download payment to my bank account when the funds have cleared.

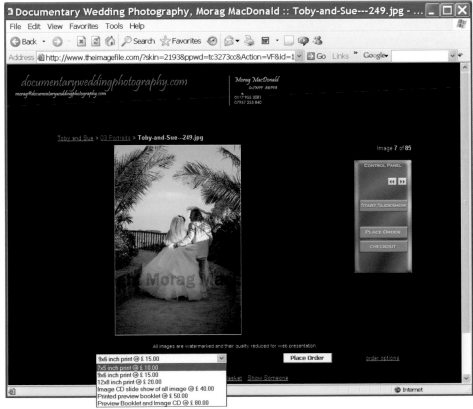

Web-hosting company, The Image File, builds in a secure payment service so clients may order prints at any time of day or night and from anywhere in the world. All you have to do is set out the products you offer, prices and payment terms. There is an option to view each folio as a slide show with music, which makes it a great way for clients to view their wedding. Family and guests can also browse through the images.

## Album Design

**When the proofs have gone off to the clients and they have made their selection of images, the last job is to design and produce their album.**

*Whether you decide to design your album on paper or opt for one of the new and innovative software packages, there are a few things to remember. The album is the ultimate place for the images so it should represent the ebb and flow of the day. A great photographer should also be a great storyteller. The images in the final album should capture the events and emotions as well as the personalities of the day. It is advisable to guide the couple a little when they are choosing the images for their album. Explain why the details are important and suggest including or substituting images where you feel you could improve the selection. If you explain that they will get a much better album as a result, most clients will be happy for you to take the lead.*

*There is a wide range of albums on the market. Covers come in all colours, textures and materials from classic leathers to stainless steel, brushed aluminium, wood, acrylic and even glass! In the inside you can use overlays to mount your work, design magazine style pages and create your own custom cut mounts with the aid of software. With such a wide choice available, it is important to limit what you offer your clients to the ranges that you are familiar with and excited about. This way your enthusiasm for the product will rub off on your customers.*

*Designing a wedding album can be made easier using one of the many album design software programs that are available. Many will allow you to be creative and build libraries of individual templates and page styles; some allow you to drag and drop images to build pages for magazine style albums, others have powerful montage software built in.*

An example of leather and brushed aluminium album covers. As the cover, spine and pages can be designed, each album is unique. Telling your client they will get a truly bespoke album is a great selling point

These albums are hand built in Australia by Albums Australia using the highest quality materials and shipped anywhere in the world. You may include up to 60 pages and choose from matted albums with overlay system, slip in or magazine style albums.

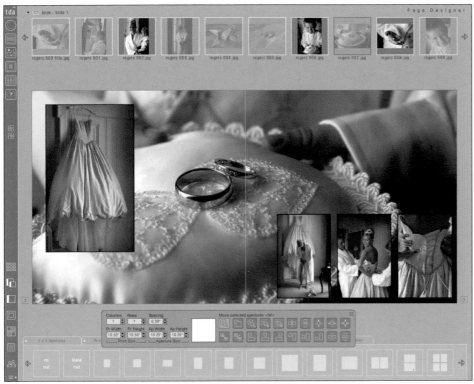

*It is advisable to guide the couple a little when they are choosing the images for their album.*

An example of the album page design screen in Album Australia's TDA software. The images along the top row are those selected by the client. Once an image has been used it changes in opacity. There is also a composite design screen where you may make up magazine style pages such as this one. As well as dropping images into pre-designed templates, you can easily arrange, resize and rotate your own images adding coloured stroke lines and changing layer opacities to obtain your desired effect. You also have the option to save your pages as templates for future use.

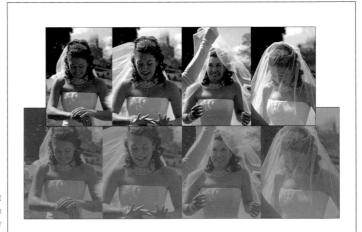

Page designs don't have to conform to pre-set templates. Having fun and keeping an eye on current trends in graphic design will keep your albums fresh, stylish and up to date.

## Design Tips

*The order of the images is important, but you must also think about how they sit together on the page.*

**Once you have settled on a range of albums and learned to use your choice of design software, then the fun begins as you start to build your album. It is good practice to include some sort of title page with all the important details such as names, dates and places. Remember that a great wedding album is also an historical record and will become a treasured heirloom for many years to come.**

*Keeping to the natural flow of the day helps to build the narrative. The order of the images is important, but you must also think about how they sit together on the page. I usually try to keep black and white and colour images on separate pages; but all 'rules' are there to be broken so I will also mix images occasionally for dramatic effect and sometimes hold an image back from early in the day because it may work well as the final image in the album.*

*Instead of single pages, it is good advice to think in terms of spreads. The viewer's eye will move across the open page, flitting from side to side, so building coherence into the design will make viewing more pleasurable. The shapes the images create on each side of the spread need to work together, try to think like a designer - the negative space on the page can become just as important as the images.*

*I design using Albums Australia's TDA (Total Design Ability) software. This has the advantage that you can decide exactly where you want the images to go. There are pre-sized apertures that can be dragged and dropped onto the page, or you can create your own custom-sized apertures, which means that the sky is the limit when making up the pages. When you have completed a page that you particularly like, there is the option to save it as a template. I find it helps me work more quickly to use my saved templates and just design new pages for specific images.*

A spread from an album showing both a matted page, where the images are slipped in behind overlays, and a 'full bleed' or 'panorama', where the image is mounted flush to the edge of a page.

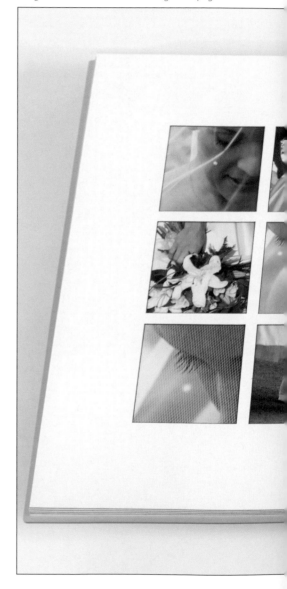

*The interface of this software is very easy to use: the program imports low- resolution versions of the images so you can work speedily without handling the high-resolution files. TDA is fully integrated with Adobe Photoshop so any changes you do to an image will be recorded. Once your album is complete, the program will instruct Photoshop to resize the high-resolution files and drop them into a new folder ready to go off to the lab.*

*My albums are ordered online through the TDA software. When one has been constructed and shipped, I check through the prints from my lab and assemble the album. When my customer picks up the finished album, it is presented in a stylish black briefcase, so finishing off the presentation perfectly.*

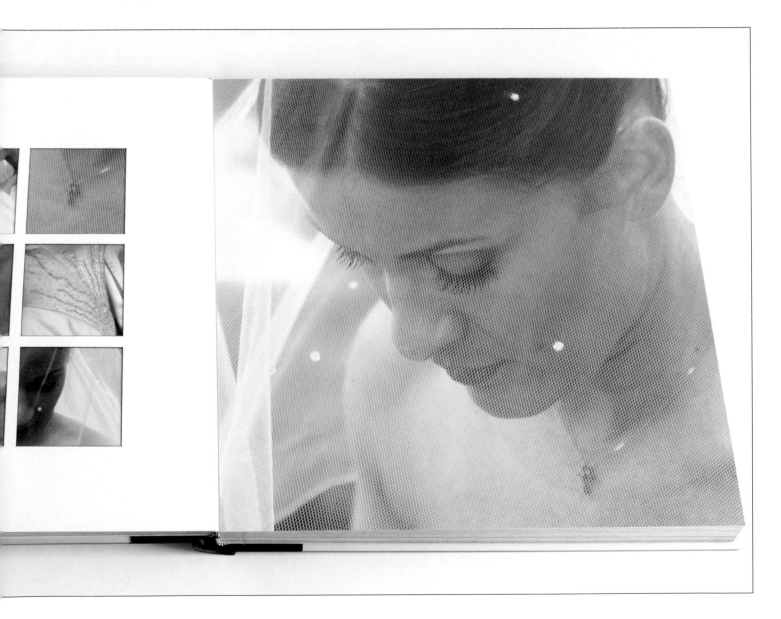

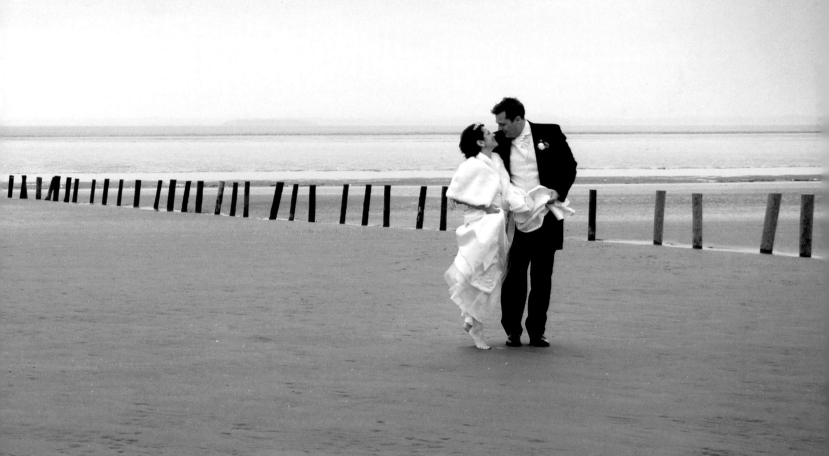

# Chapter 6 *The Digital Darkroom*

# Working With Your Images

Remaining true to the photographic look will give your work integrity.

**Shooting digitally has many benefits, not least the fact that you have complete artistic control over your images. You may crop, tone, retouch, convert to black and white or add effects to suit the tastes of your client. It is you who decides how much you do to your images, perhaps only making subtle changes to begin with and becoming more adventurous as you gain experience.**

When approaching images in the 'digital darkroom', I try to treat them as I would have in a traditional 'wet' darkroom. Remaining true to the photographic look will give your work integrity. As you work on your images you should aim to enhance rather than create them. Some shots do benefit from a stronger 'digital look', but keeping these to a minimum will give them greater impact.

A skilled photographer will always strive to get the best possible image at the moment of capture. This is true regardless of workflow, even when working with RAW files, where the camera settings may be tweaked later. A disciplined and talented photographer will save hours of processing time by producing great files to start with.

Adobe Photoshop is the pivotal software in the arsenal of the digital photographer. But Photoshop is memory hungry and working with large layered TIFF files can be very time consuming (for more on file handling see pages 98-99, Digital Workflow). Try to keep this in mind when you are shooting as it will remind you to try to achieve the best possible exposures and composition in camera.

Over the following pages I will introduce the digital processes most used in my studio.

Nikon D100, Nikon ASF 28-70mm f2.8 lens, ISO 400, 1/1500, f2.8

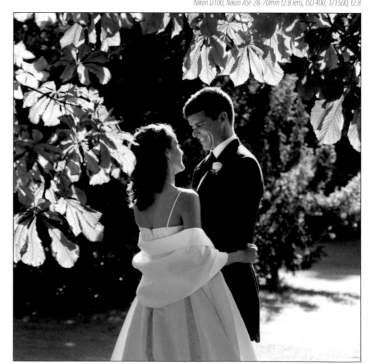

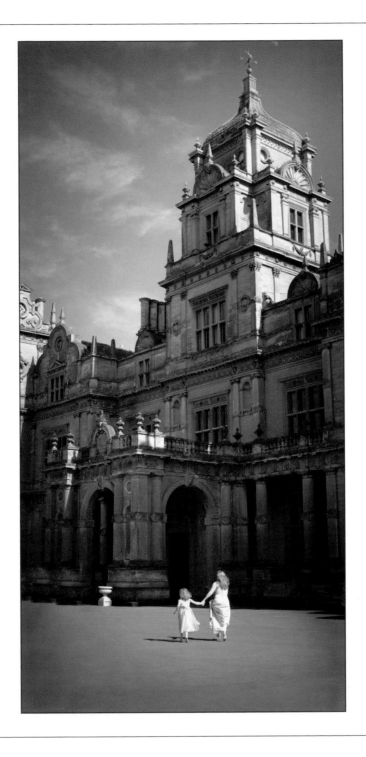

*Nikon D2x,*
*28-70mm f/2.8 lens,*
*ISO 100,*
*1/200sec at f/7.1*

# Basic Image Manipulation

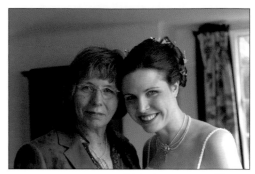

Original , unprocessed image.

**When opening your images on the computer, the first thing to carry out is a tidy up job. Photoshop enables you to complete these tasks in a quick and fluid manner.**

**Tone and Density:** *Start by assessing your image for tone and density. If your image is too dark, it may be lightened by moving the midtone slider in Levels (Image>Adjustments>Levels or ctrl+L) towards the shadow area or adjusting the line in Curves (Image>Adjustments>Curves or ctrl+M).*

**Colour:** *If the colour of the image needs to be addressed this can be done in Color Balance (Image>Adjustments>Color Balance or ctrl+B). Here you may adjust individual colours in the midtones, shadows and highlights separately. Remember you are working on the overall colour balance so it will affect the whole image. You can also change the balance of individual colours by using Selective Color (Image>Adjustments>Selective Color).*

**Cropping:** *When you are happy with the overall look of the image, you may wish to crop it to achieve better framing. The image on this page is a simple shot, which shows the closeness between mother and daughter. The emotion is signified by the tears that are just beginning to form in the mother's eyes. I decided to crop the image to make it more intimate. I did this by selecting the Crop tool from the Tool Bar. (If your Tool Bar is not showing then go to Window>Tools and select the Crop tool).*

**Retouching:** *I then tidied up the image a touch. Using the Clone tool you may reduce shininess, wrinkles and blemishes. Enlarging the image, so that I could work on a small area at a time, I selected the Clone tool. I chose a small soft brush and Opacity of about 20%. I selected an area of clear skin (by holding down the Alt key and*

To crop your image, select the Crop tool from the Tool Bar and drag it across the image. You may resize the area by clicking and dragging the edges and corners of the selected area.

*clicking on the target area) and gently worked the area I wished to soften by brushing the Clone tool over it. You should be careful not to over work your image. To keep a natural look, shininess and wrinkles should be softened but not taken out. At regular intervals reduce the size of the image and view it as a whole to check that you have not gone too far.*

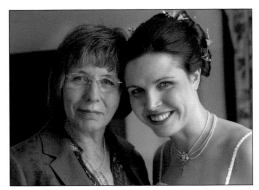

Cropped and retouched image. Notice that after retouching, the integrity of the original image is not compromised. To retain a natural look, any retouching should be kept to a minimum.

*Other useful tools are the Patch tool and the Spot Healing Brush tool. With the Patch tool you may select a clean area and drag it across to other areas; the Opacity will automatically change to blend with the target area. The Spot Healing Brush tool is particularly useful when removing smaller blemishes. It will copy the pixels around the selected area and in most cases does a quick and effective job.*

**Adding Diffusion:** *To create a subtle soft focus effect, two new layers need to be created from the Background layer. Go to the Layers palette and drag the Background layer onto the New Layer icon (circled in red and numbered 1) to get a Background Copy layer. Repeat to get a second. With the top layer selected, go to Filter>Blur>Gaussian Blur and select a radius of around 10%. Hit OK and return to the Layers palette. Change the blending mode to Multiply (circled and numbered 2) and your image will appear less diffused and somewhat darker. Right click on the top layer in the Layers palette and select Merge Down.*

*You should now have two layers, the Background and the darker Background Copy layer. With the top layer highlighted, lighten the image by sliding the midtone levels slider (ctrl+L and slide the middle*

*slider). You may toggle between the layers by turning the eye icon next to the top layer off and on.*

*When you have a pleasing match in tone it is time to add some selective focus to the image. Select the Eraser tool from the Tool Bar, set the Opacity to 40–50% and make sure you have a soft brush. You can now erase areas of the top layer to reveal the focused layer behind. Whilst keeping a soft diffusion in flesh areas, I brought the eyes, mouth, hairline, and the lower part of the nose back into focus. I then worked on the bride's necklace, the edge of her mother's clothing and areas in the hair, thus producing a soft image but with all the important detail retained.*

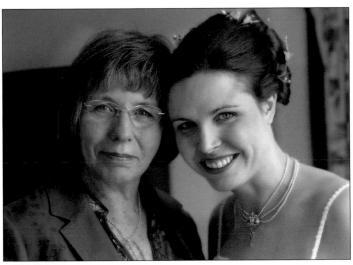

Final image.

# The Beauty of Black and White Photography

Nikon D100, 28-70mm f/2.8 lens, ISO 400, 1/80sec at f/4

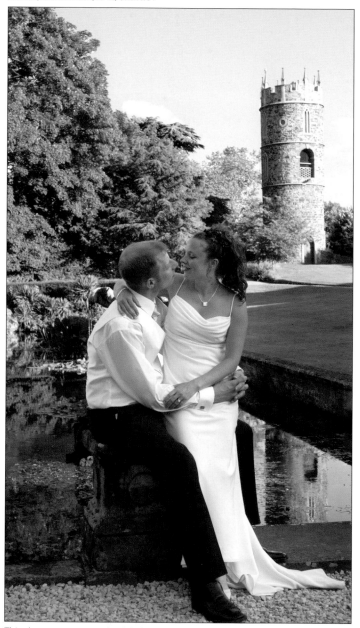

This shot was converted to black and white using the Channel Mixer.

**The beauty and impact of black and white photographs gives them a timeless quality, making them ever popular with brides and grooms. Achieving superb black and white prints is the ideal that every wedding photographer should aspire to.**

There are many ways to convert your colour shots to black and white within Adobe Photoshop. It is worth bearing in mind that the most simple are not necessarily the most effective. By trial and error you will find the conversion method that gives you the best look for your images. I tend to save different methods (or recipes) as Actions. This allows me to choose a preset method and run the action, either to convert single images or to batch process a group of images.

When converting your images to black and white, it is advisable to work in a new layer or an adjustment layer. This gives greater flexibility as you may go back to the original if you make a mistake. I also sometimes find that a couple may like an image in black and white but their parents prefer it in colour.

**Desaturate:** *Image>Adjustments>Desaturate (shift+ctrl+U) gives you the most simple conversion. Saving the black and white version as another layer means you may always revert to the colour file if need be. You may tweak your image using Levels and Curves.*

**Grayscale:** *Image>Mode >Grayscale. With this method of conversion you are simply throwing away all of the colour information. This is a basic and limiting operation as the colour information is not retained. As you change the colour mode you are not able to work in Layers so it is advisable to do a 'save as' command (File>Save As or ctrl+shift+S) so you are working on a copy of the image whilst still retaining the original.*

**LAB Color:** *This gives good tonality from highlight to shadow. Again, as you are changing the colour mode (so not able to retain the RGB colour layer) it is sensible to work on a copy of your image. To convert your image select: Image>Mode>Lab Color. Open the Channels*

palette (Windows>Channels) and select the Lightness channel. The image will now appear in black and white. To get rid of unnecessary channels, click on the 'a' channel and drag to the waste bin. Finally, to convert your image back to RGB, go to Image>Mode>Grayscale>RGB.

**Channel Mixer:** *This is probably my favourite way of converting an image to monochrome. With this method you are able to adjust the amount of each colour in the image, just as you could have worked with colour filters over the lens with black and white film. A red filter with black and white film increases the intensity of blue skies and the contrast in the image, an orange or yellow filter would have a more*

gentle effect, while a green filter makes foliage appear lighter. By working in an Adjustment Layer you have the added benefit of being able to revisit and change the settings later. For more on the Channel Mixer see overleaf, pages 114-115.

**Hue/Saturation:** *Just as with the Channel Mixer method of conversion, using the Hue/Saturation method is an excellent way to work when you want complete artistic control over the final image. You can simulate the effects of filters and change images to increase their dramatic impact. For more on this method of conversion, see pages 116-117.*

*Nikon D2x, 28-70mm f/2.8 lens, ISO 200, 1/250sec at f/2.8*

This was converted to black and white using the Hue/Saturation method (see pages 116-117).

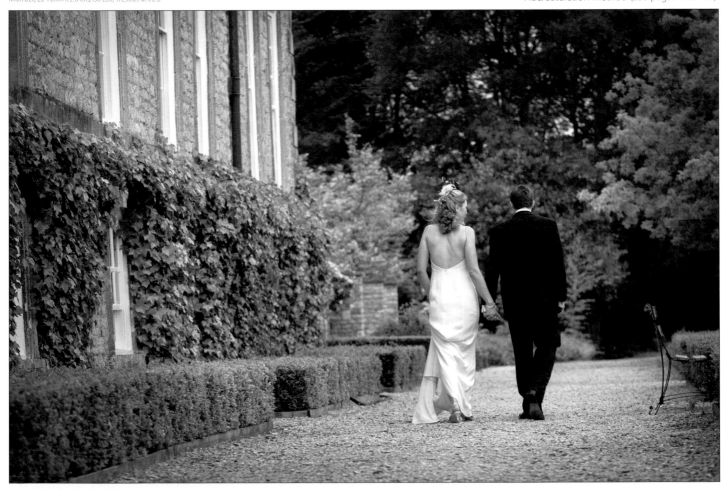

## Working with Layers and Channel Mixer Conversions

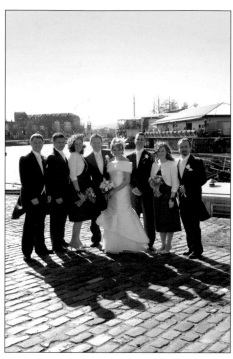

Nikon D2x, 28-70mm f/2.8 lens, ISO 100, 1/320sec at f/6.3

**To create a black and white image with the Channel Mixer, first open your colour image in Photoshop and then create a second layer: open the Layers palette, click on Background layer and drag it down onto the New Layer icon. Double click this copy layer and rename it B&W. With the new layer highlighted, create a Channel Mixer Adjustment Layer by clicking on the Adjustment Layer icon (a half black and half white circle, circled) and scroll down to Channel Mixer.**

*The Channel Mixer box now opens. Click Monochrome at the bottom of the box and the image will change to its default black and white setting. You will see three sliders that allow you to choose the amount of the Red, Green and Blue channels. You may now adjust the sliders to obtain the most pleasing balance for the image you are working on. As the amounts represent percentages, the combined figures should total 100. This will ensure that there is no clipping of the highlight or shadow areas, though you may on occasion wish to ignore this rule to create a different effect.*

*When an image is converted to Grayscale in Photoshop, it is made up of roughly the following percentages of RGB: Red: 30, Green: 60 and Blue:10. This formula gives a well-toned conversion but it is worth experimenting with other combinations to achieve different looks. For my image, I wanted to enhance the sky so I put more red into the mix whilst reducing the Blue channel – Red: 56, Green: 40 and Blue: 4.*

*I decided that the sky could be further enhanced and I wanted to burn in the edges of the image a little. Making sure I had selected the B&W layer in the Layers palette, I then selected the Lasso tool from*

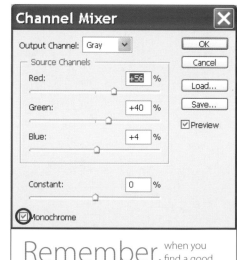

Remember, when you find a good Channel Mixer recipe, save the settings as a Photoshop 'action'. You may later use the action to batch convert multiple images that you feel will benefit from that mix.

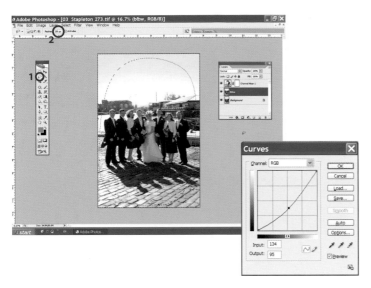

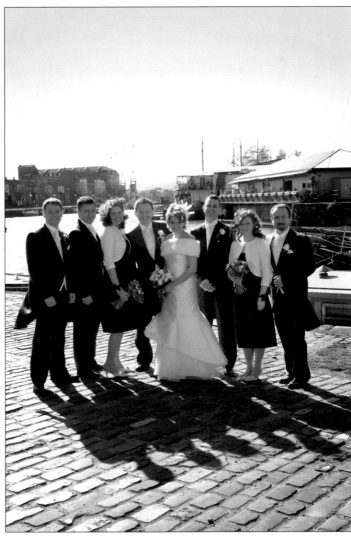

the Tool Bar (circled in red and numbered 1). I chose a soft feather of 250px (circled and numbered 2) and roughly circled the subjects of the image leaving the area I wished to burn in. Next, I inverted the selection by hitting ctrl+shift+i (I) (now just the outside of the image is selected), and opened the Curves dialogue box by hitting ctrl+M.

In the Curves box I clicked and held the central point and dragged the cursor downwards until I felt that the outside of the image had darkened enough. I clicked OK to close the box and reviewed my image.

At any stage you may go back and change the Channel Mixer settings in the Adjustment Layer. To do this you must double click the Adjustment Layer icon (the Channel Mixer dialogue box will appear) and then slide the sliders to get the desired effect. If you are completely happy with the image and want to make no further changes, click your mouse with the cursor on the Channel Mixer Adjustment Layer and choose Merge Down from the menu. This will leave a single monochrome layer (with all of the changes in place) and the original colour image as the Background layer.

# Hue and Saturation

**Martin Evening's book 'Photoshop CS2 for Photographers' contains another way of converting to black and white, which also gives you a great deal of control over the tonal values of the image. This is achieved by using dual Hue/Saturation Adjustment Layers. I have started using this method recently and I have become quite addicted to it. There is great scope for producing stunning images.**

*Start by opening a colour image with any retouching already done. Open the Layers palette and create a Hue/Saturation Adjustment Layer by clicking on the Adjustment Layer icon (a circle half toned black and half white) and selecting Hue/Saturation from the menu. In the Hue/Saturation dialogue box that appears, slide the saturation slider down to -100 and hit OK.*

*Nikon D2x, 28-70mm lens, ISO 100, 1/60sec at f/6*

*This gives you a basic de-saturated image. Next select the Background layer in the Layers palette and add another Hue/ Saturation Adjustment Layer (following steps above). Make no adjustments, click OK and return to the Layers pallet.*

In the top left of the Layers palette, change the blending mode to Color and re-open the second Hue/Saturation dialogue box (by double clicking the layer thumbnail).

By moving the Hue slider you may alter the image in much the same way as changing the blend of the Channel Mixer on the previous pages. You may also change the Saturation and Lightness sliders to further enhance your image. I chose a mix that had the effect of lightening the tones in the leaves behind the group as well as brightening flesh tones and putting more detail into the shadow areas.

## Sepia and Soft Tone Images

*I decided to create some soft-toned images to evoke the feel of a time gone by in these portraits taken at a railway station (see pages 80-86). I wanted the images to have a sepia feel but with a hint of colour coming through.*

 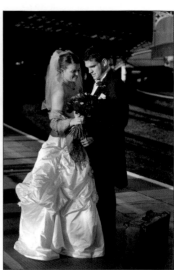

*Nikon D2x, 28-70mm lens, ISO 100, 1/500sec at f/6*

The original colour version and (right) converted to black and white with Channel Mixer.

*To achieve this, I did a black and white conversion in a Background Copy layer. I used the Channel Mixer, ticking the Monochrome box and with a recipe of Red: 40, Green: 50, Blue: 10 (for more on Channel Mixer see pages 114-115). This layer was named 'Sepia'.*

*To create a sepia effect, I added a Hue/Saturation Adjustment Layer. To do this I clicked on the Adjustment Layer icon at the bottom of the Layers palette and selected Hue/Saturation. In the dialogue box that opened I ticked the Colorize box. When this box is ticked it goes to its default Saturation of 25 and the image turns a reddish colour. By moving the Hue slider you will be able to choose the best colour.*

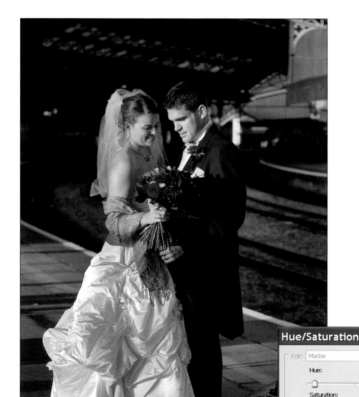

When I found the shade I wanted, I reduced the Saturation from 25 to 17 to give a soft sepia look. When you are happy with the colour, click OK to close the box. If you wish to make no further adjustments, right click your mouse over the Adjustment Layer in the Layers palette and choose Merge Down from the menu.

You now have two layers in the Layers palette, the Background layer and a Sepia layer. To bring a little colour back to the image, make sure that the Sepia layer is highlighted in the Layers palette and select the Eraser tool from the Tool palette. Choose a soft-edged brush and a Flow and Opacity of 10-16% and begin to gently paint colour back into you image by erasing parts of the Sepia layer. I usually start with a large, more general brush and work in sweeping strokes. I will later go back with a smaller brush to enhance any details. In the finished version, I burned in the edges as well as a few distracting white details in the background. The image has a certain softness as well as the dramatic, cinematic look that I was aiming for.

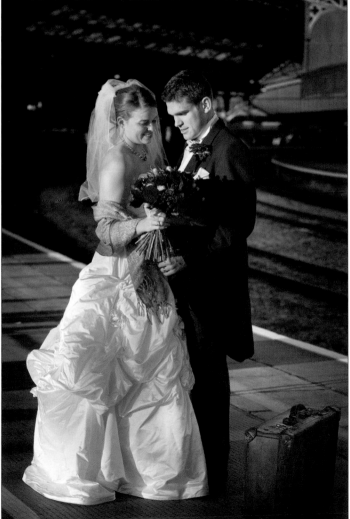

# Toning

Nikon D2x,
28-70mm f/2.8 lens,
ISO 200,
1/250sec at f/4.8

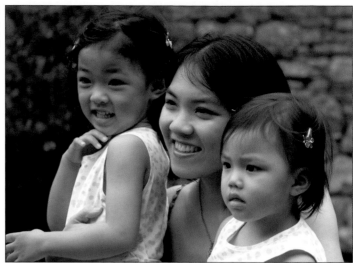

The original black and white image without any added tone.

*There are many ways of toning images in Photoshop. You may tone both colour and black and white images to good effect but the latter is used as an example here.*

**Photo Filters:** *Photoshop has a number of built-in Photo Filters. These are mainly designed to compensate for colour castes in scanned colour film, or where the images were not shot in RAW file format. They do, however, also include a Sepia filter and different colour filters that may be used with any image.*

When experimenting with toning remember to work in a separate layer so that you may always return to the original image if you do like the result.

To experiment with Photo Filters go to Image>Adjustments>Photo Filters. In the Photo Filter dialogue box make sure that the Preserve Luminosity box is clicked. There is a drop down menu containing a number of filters; the depth of colour may be altered by moving the density slider.

**Hue/Saturation:** *A simple way to tone a black and white image is to use a Hue/Saturation Adjustment Layer. In the Layers palette, duplicate the Background layer by clicking and dragging it onto the New Layer icon at the bottom of the palette. With this new layer*

highlighted, make a Hue/Saturation Adjustment Layer by clicking on the Adjustment Layer icon (a circle, half black and half white), and select Hue/Saturation from the drop down menu.

In the Hue/Saturation dialogue box that opens, click the Colorize option. The image will turn its default Red (Hue 0 and Saturation 25) and you can now change the hue by sliding the Hue slider through all the colours. Once you have selected the colour you wish to use, you may change its intensity with the Saturation slider.
You can also make very dense or very soft images by sliding the Lightness slider. This is especially useful when constructing magazine-style pages and you want an image with low density to work as a backdrop for other images.

**Split-toning:** *I used to teach students in a traditional wet darkroom. One of the things we enjoyed was toning black and white prints. Certain chemicals affect different parts of the image at different rates and, with some experimentation, my students produced beautiful prints where the deep shadow areas were one colour and the mid tones or highlights another. Such is the nature of chemical toning that one tends to work instinctively, removing the print from one chemical and plunging it into the next when you think it looks right. This makes it hard to achieve the same result twice. In Photoshop you can emulate these processes by separating the tones,*

safe in the knowledge that the exact tone can be repeated across a number of images.

To achieve this effect make sure that you are working in a Background Copy layer so that you still retain your original, add a Color Balance Adjustment Layer by clicking the Adjustment Layer icon. Make sure the Preserve Luminosity box is clicked. You may now select which of the tones you wish to bring colour to.

For my image, I first chose the shadows and dialled a little blue in, then warmed the highlights where I dialled in 16 yellow and 3 red. I kept the blending mode of the Adjustment Layer as Normal, which increased the contrast making the shadow areas more dense. If I had chosen to change the blending mode to Color, the luminosity of the layers below would have been preserved.

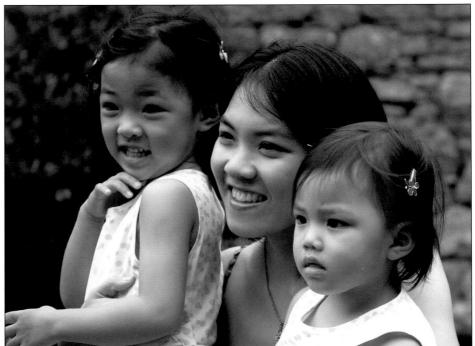

For this image I chose to keep the split-tone effect subtle, just adding a little depth to the darkest tones in the shadows and hair and a gentle warmth to the highlights. With experimentation, split-toning can be used to create many different effects.

## Spot Colouring

**To create spot colouring in images, you work in much the same way as the soft tone image on the previous page. Make a New Layer from the Background layer and convert to black and white by your chosen means (for this image I used the Channel Mixer).**

*Once you are happy with the black and white layer, you may simply rub away part of this layer with the Eraser tool to reveal the colour image underneath. When using this tool, care must be taken to get nice clean edges.*

Photoshop is a powerful tool, but you must not just rely on your computer skills to create impact in your images. It is the image that you capture within the camera that has to stand up to scrutiny. It is your skill as a story teller that will make an album really speak to your client. It is your passion and energy that will shine through the pages.

Creating images that are fun, spontaneous, emotional and spirited is a skill indeed. But if you love what you do and the people you photograph, your job will be that little bit easier.

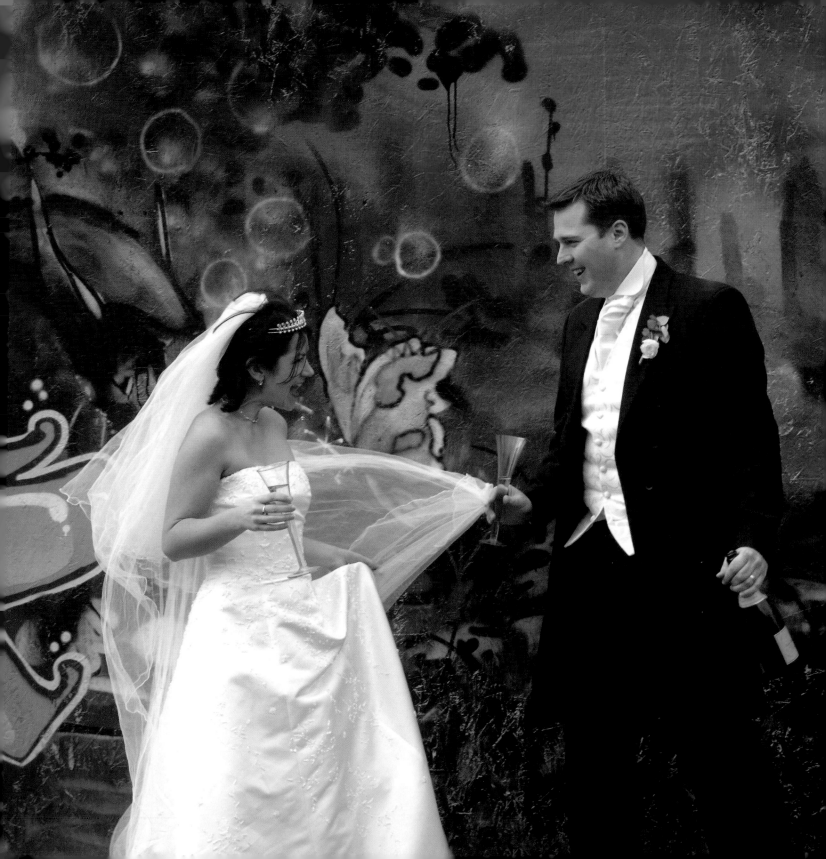

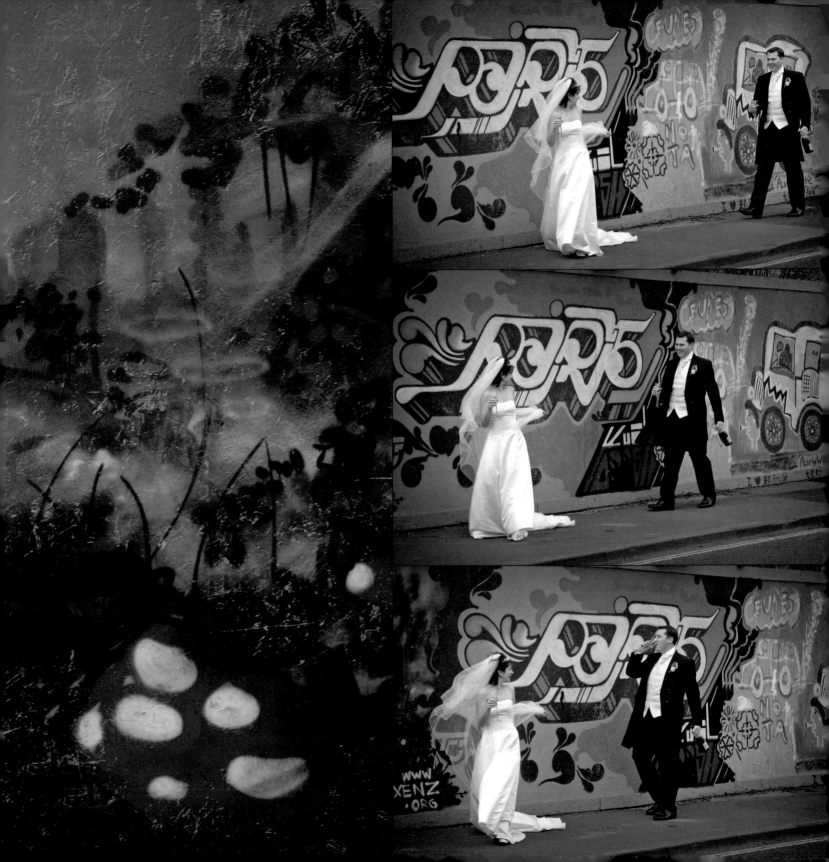

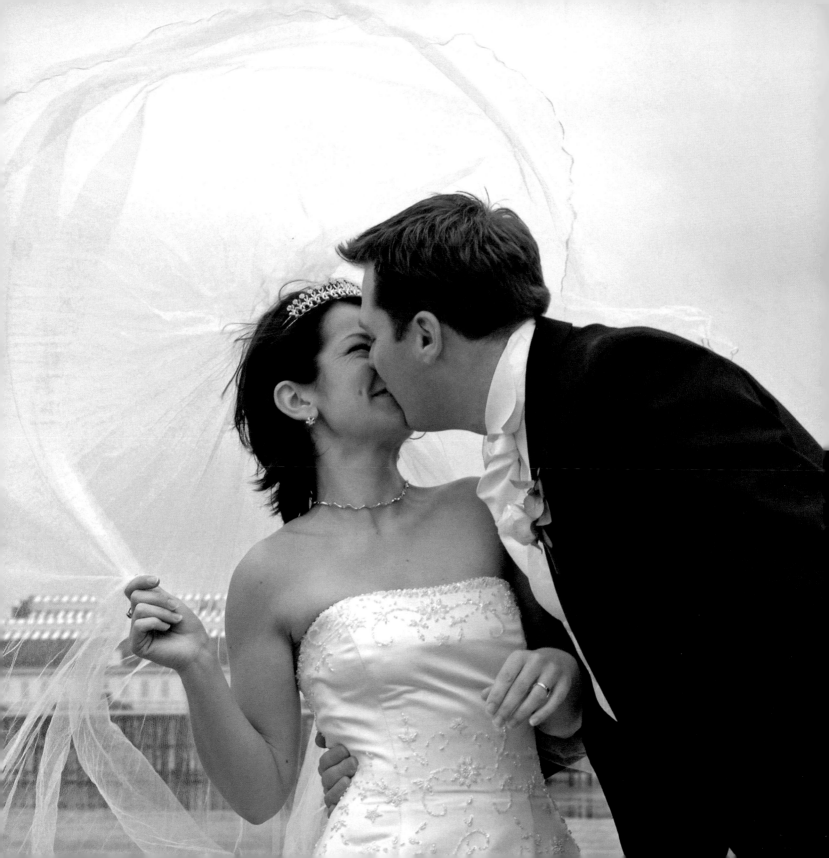

## Acknowledgements

*A big thank you to all the couples who have given me the pleasure of photographing their weddings. Particularly to Anna and Stephen and Dani and Simon. Thanks to Joe Buissink who kindly donated images for this book, you are an inspiration to me. To all those who have worked with me as second photographer, especially Jane Bramley, Jane Chmiel and Kiran Ridley, whose images feature within these pages. To Angie Patchell, for visualising this project and giving me the support to see it through. To Cathy Joseph for editing this book. For the beautiful design, thank you Toby Matthews. To my suppliers, especially Andy and the team at Clifton Colour, Calumet Bristol, Moss Bros, Kingston, and to Albums Australia (for creating perfect albums).*

*The biggest thanks go to those closest to me. To Ian, my husband, you are my best friend, thank you for having faith in me, I love you. To our children, Rudy and Izzi, you are just the best! To my father for giving me my first 35mm camera at the age of 12, and to my mother for bringing me up to follow my dreams.*